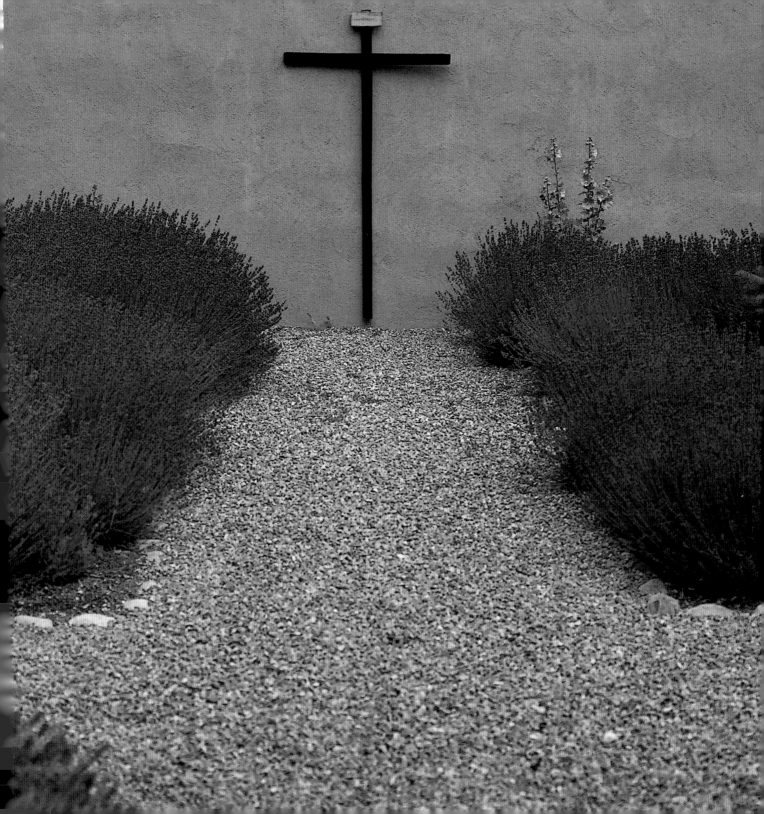

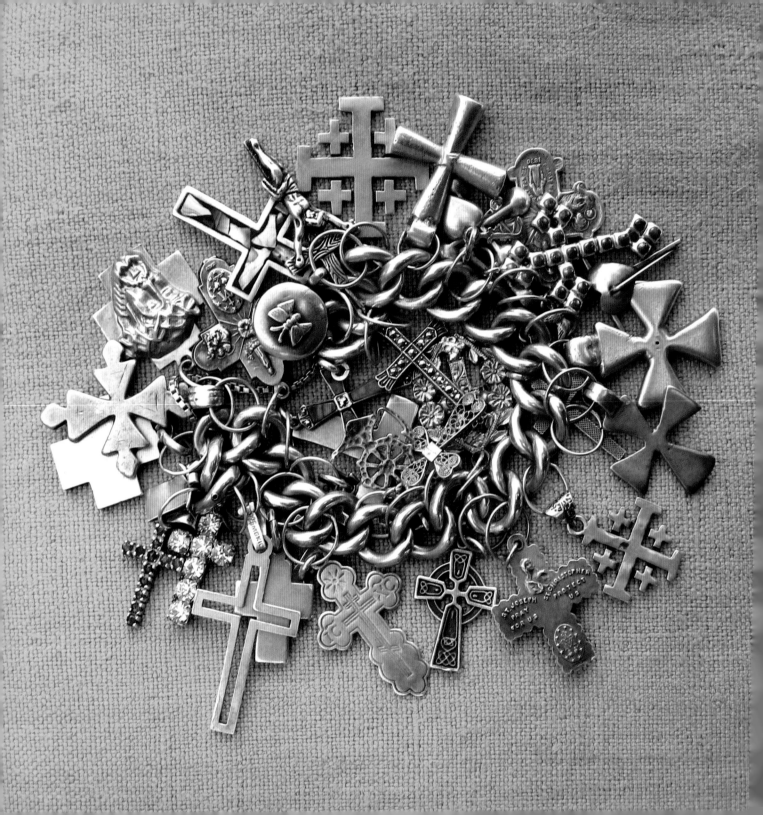

ART
OF THE
CROSS

MARY EMMERLING

PHOTOGRAPHS BY JIM ARNDT

Ancient City Press

AN IMPRINT OF GIBBS SMITH, PUBLISHER

Salt Lake City | Charleston | Santa Fe | Santa Barbara

First Edition
10 09 08 07 06 5 4 3 2 1

Text © 2006 Mary Emmerling
Photographs © 2006 Jim Arndt

Published by
Ancient City Press
An imprint of Gibbs Smith, Publisher
P.O. Box 667
Layton, Utah 84041

Orders: 1.800.835.4993
www.gibbs-smith.com

Design by Gabriella Hunter
Printed and bound in Hong Kong

ISBN 1-4236-0115-7
Library of Congress Control Number: 2006927833

Dedicated to Reg Jackson and our search for crosses.

With much love, '+' —ME

Dedicated to Nathalie. —JA

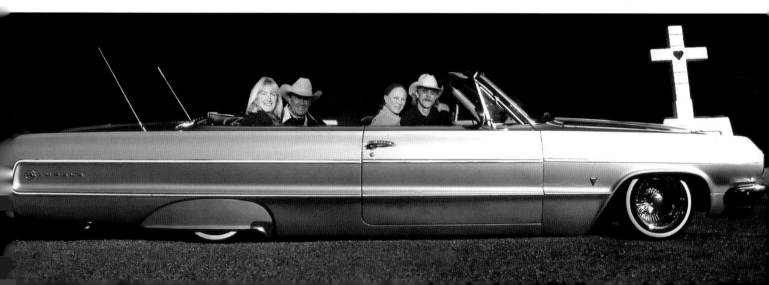

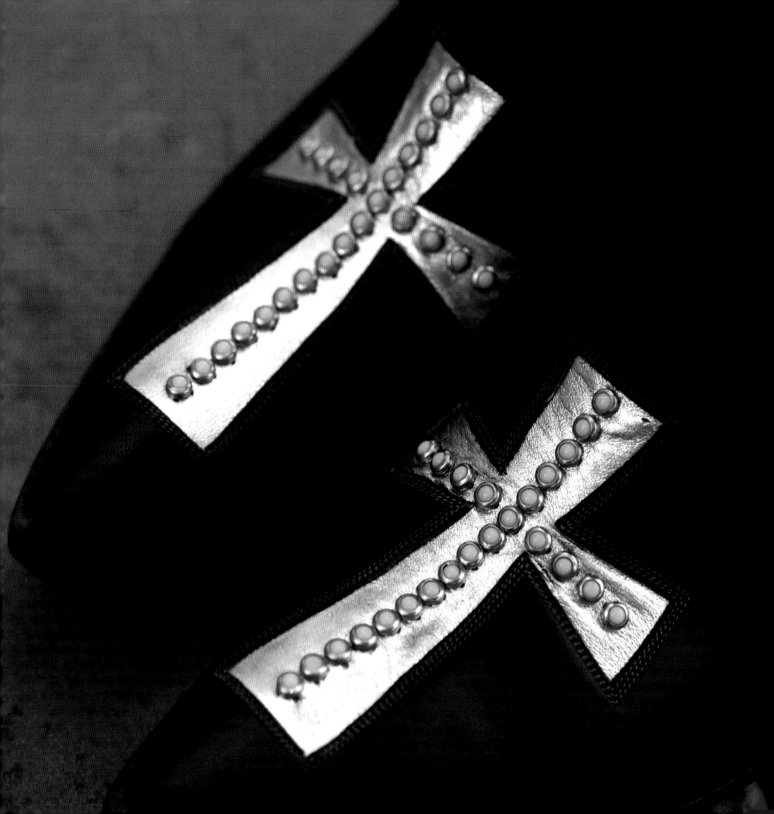

contents

◆ ◆ ◆ ◆ ◆

Acknowledgments ..8

Introduction ...10

Beadwork and Basketry ...14

Textiles ...28

Leatherwork ..38

Candleholders and Decor...48

Religious Iconography ..60

Jewelry ...72

Metal, Stone and Wood ...98

Architectural and Outdoor Ornaments..120

ACKNOWLEDGMENTS

♦ ♦ ♦ ♦ ♦

A big thank-you to Jim Arndt, a thoughtful and wonderful photographer.

Special thanks to all the people I have learned from, bought from, and given or gotten cross gifts from all these years. Thanks to Reg Jackson, Nathalie Kent, Patti Kenner, Carol Glasser, Peter Vitalie, Dianne Cash, Ann Lawrence, Gloria List, Jane Smith, Terri Schurmeier, Nevena Christi, Wendy Lane, Barbara Trujillo, Buffy Birrittella, Doug Bihlmaier, Sue Balmforth, Jed Foutz, Pam and Bob Melet, Randy Rodriquez, Carter Berg, Mary Randolph-Berg, Lyn Hutchings, Jen Kopf, Beverly Jacomini, Liz Pierce, Don Ziebell, Carol Anthony, Theo Raven, Kristin and Dan Alber, Georgia Bates, Becky Pryor, Nancy Reynolds, Charmay Allred, Carol Sheean, Ellen Windham, Barbara Carlton, Susan Victoria, Taryn Vanderford, Rebecca Lankford, Heidi Kurash, Amy Johannsen, my editor Madge Baird, and all the antiques dealers I have learned from and bought from the last twenty-five years.

And thanks to my brother, Terry Ellisor, and to my children, Samantha Emmerling and Jonathan Emmerling, who have lived with my passion for crosses all these years.

MARY EMMERLING

My thanks go out to Mary and Reggie for all their help and support on this book. And to Madge Baird for making this book happen. Also a huge thank-you to all the collectors and friends who helped put this together. The biggest thank-you to my inspiration for crosses, this book, and life—Nathalie.

Thank you to the contributors and friends who helped on this book:

Mary and Reg
Nathalie Kent
Sherry & Mike Maxwell
Matthew Maxwell
Jeff Hengesbaugh
Gloria List
Spanish & Indian Traders
Jan Duggan
Susan Swift
Morning Star Gallery
Micheline Delannoy
Gwendoline Hibon
Dave Little Boots
Jay Evett
Chet Vogt
Kit Carson

Loree Rodkin
Tyler Beard
Tres Outlaws Boots
Rocketbuster boots
Cassey Brei
Pam Dietrick
Clint Mortenson
Clint Orms
Lee Downey
Chrome Hearts
Federico Jimenez
Samantha Silver
Sandra & Bruce Van Landingham
Catherine Maziere
Sherrie Brody
Teri Greeves

William Cabrera
Adrienne Teeguarden
Café San Estaban
Maggie Parquet
Jan Barroglio
Konstintino
Marc Navarro
Rebecca Langford
Sherwoods Spirit of America
Fred "Mr. Lowrider" Rael
 & *Precious*
Curt Anderson
And my sister, Kathy Arndt
 Graves, whose home is
 covered in crosses.

JIM ARNDT

introduction

◆ ◆ ◆ ◆ ◆

I HAVE TRIED and tried to pinpoint the very moment crosses captured me twenty years ago. Was it the first Navajo rug I saw with crosses or the sterling silver squash blossom necklace with eight crosses framing the center naja? Was it the time I was in the Millicent Rogers Museum in Taos, New Mexico, spellbound by her personal collection of silver and turquoise Indian jewelry, many with crosses adorning them? Or was it the Santa Fe museums where I lived in my free moments?

Upon my arrival in Santa Fe, I was greeted by the state flag, which features a Zia, as well as the numerous missions and churches with their simple wooden crosses in all sizes exhibited inside and out. It was here that my romance with crosses started. They found their way into my jewelry, my western clothing, my home and my garden. I would find crosses everywhere. There were the Spanish and Indian markets, the numerous antiques shows—especially in August in Santa Fe—the Santa Fe flea market and, of course, the numerous antiques shops and shows I frequent all year long across the country.

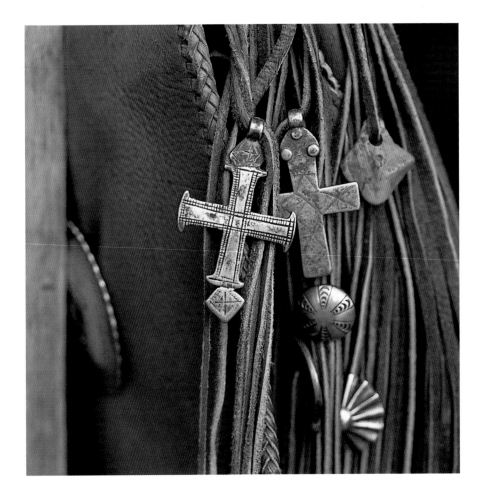

Crosses even dictated the path design of my lavender garden and culminated in the silver bolo my husband wore at our wedding in Bishop Lamy's personal chapel at Bishop's Lodge. Of course, the chapel door greeted all who visited with a beautiful hand-carved cross.

I find crosses everywhere. The search is what makes it fun. From my turquoise cross ring to the silver cross on my Filofax, the cowboy boots with crosses in rhinestones and my most prized charm bracelet with several crosses in sterling silver, rhinestones, enamel, diamonds, turquoise and rubies, all put together in the 1940s and a very special birthday gift from my great friend Patti Kenner—I love them all! There isn't a day that goes by where I am not looking for another cross to add to my collection or where I don't see one as I walk into a church for prayer. The history of the cross is timeless.

I know that crosses found on Indian pawn jewelry are probably my favorite first collection, started twenty-five years ago while I was doing *American Country West*. I stopped in every pawnshop I saw across the West. I then started decorating my apartment in New York City with more western decorative accessories from my trips. There were the chile pepper crosses and wooden crosses in all sizes, plain and with milagros. There was even an evergreen Christmas cross for the outside door.

My love of Navajo rugs was mostly for those in beige, red, black and white, but if it had a cross, I wanted it even more. Then there were the candles with crosses or a big suede purse with charms in crosses hanging on the suede fringe. I can go on and on, but now it is your turn to go looking. Happy hunting!

BEADWORK
AND
BASKETRY

◆ ◆ ◆ ◆ ◆

WITH THE COMING of the mountain men and the rendezvous in the 1800s came trade goods. These included European glass beads in wonderful colors and consistent sizes, along with steel needles, which quickly replaced the porcupine quills used prior to the fur trader's arrival.

Crosses in Native basketry were influenced by the Spanish fathers and adopted into all of the regions crisscrossed by the good priests.

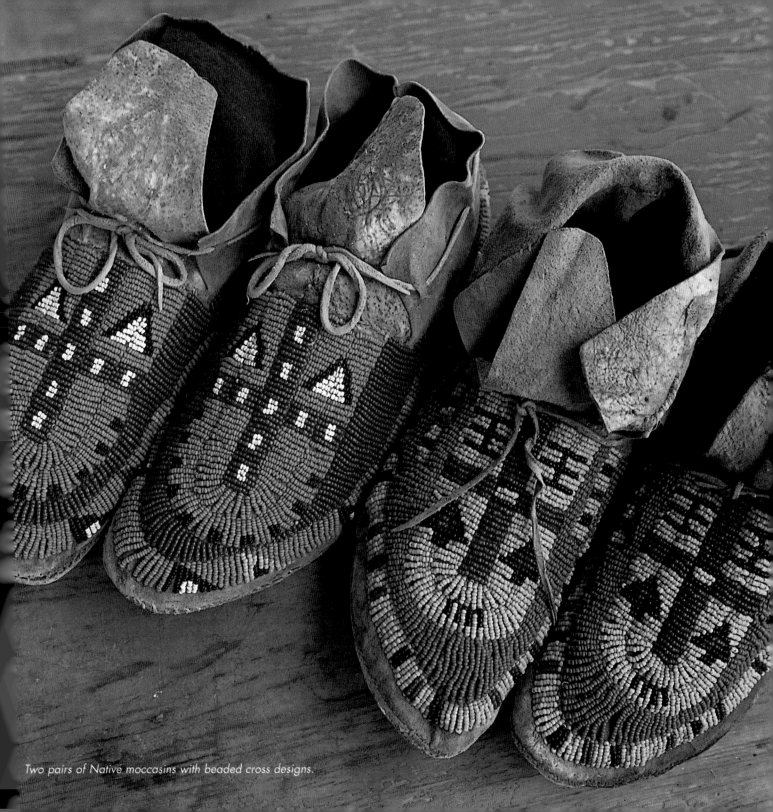

Two pairs of Native moccasins with beaded cross designs.

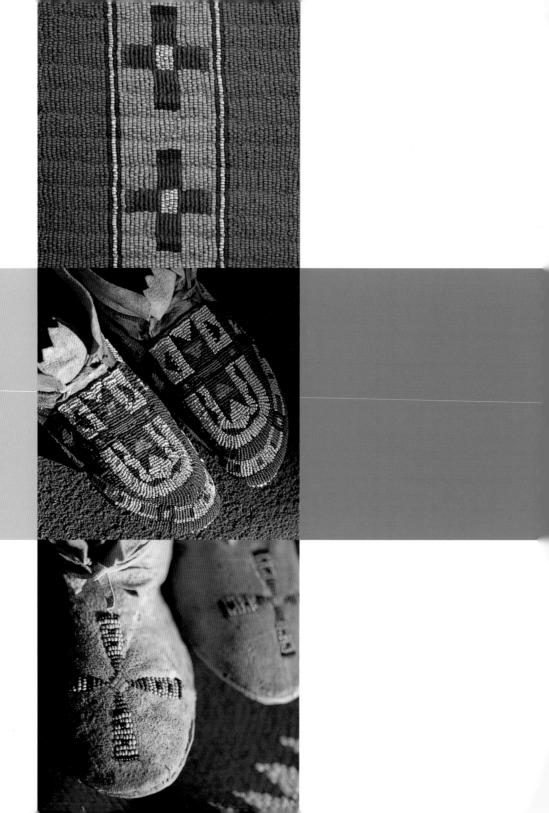

Above: *Detail of Plains Indian beading, 1800s.* **Middle:** *Beaded Plains Indian crosses on smoke-tanned moccasins, 1890s.* **Below:** *A pair of Native American smoke-tanned moccasins with beaded cross design in blue, turquoise and coral beads, ca. 1890s.*

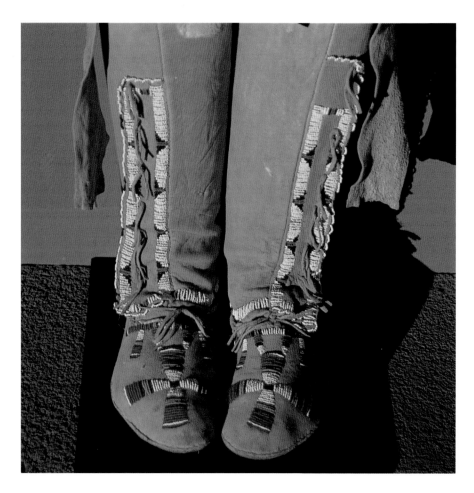

Plains Indian high tops with glass-beaded cross decoration, 1890s.

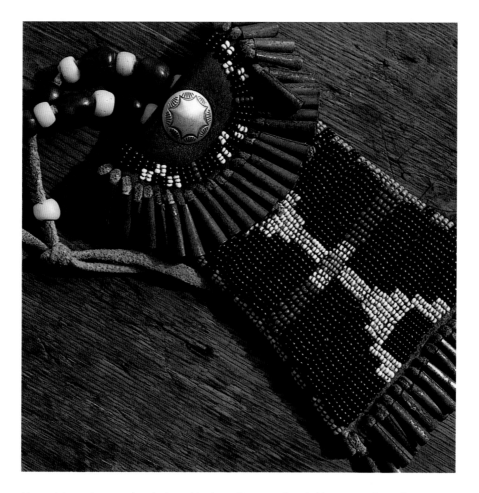

Above: Native American beaded possibles bag. *Opposite:* Beaded brain-tanned pipe bag, 1880s.

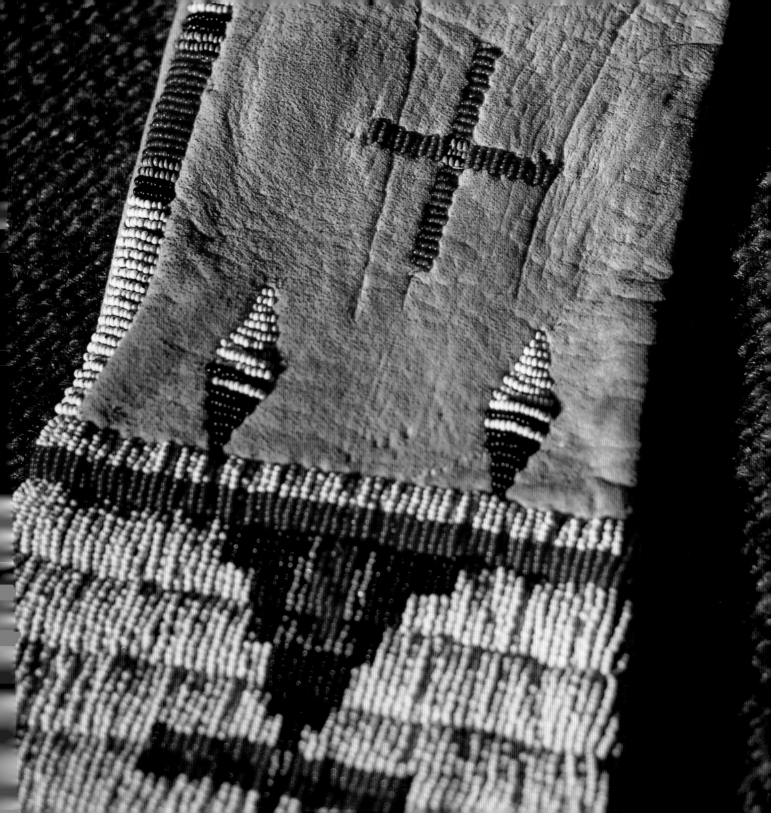

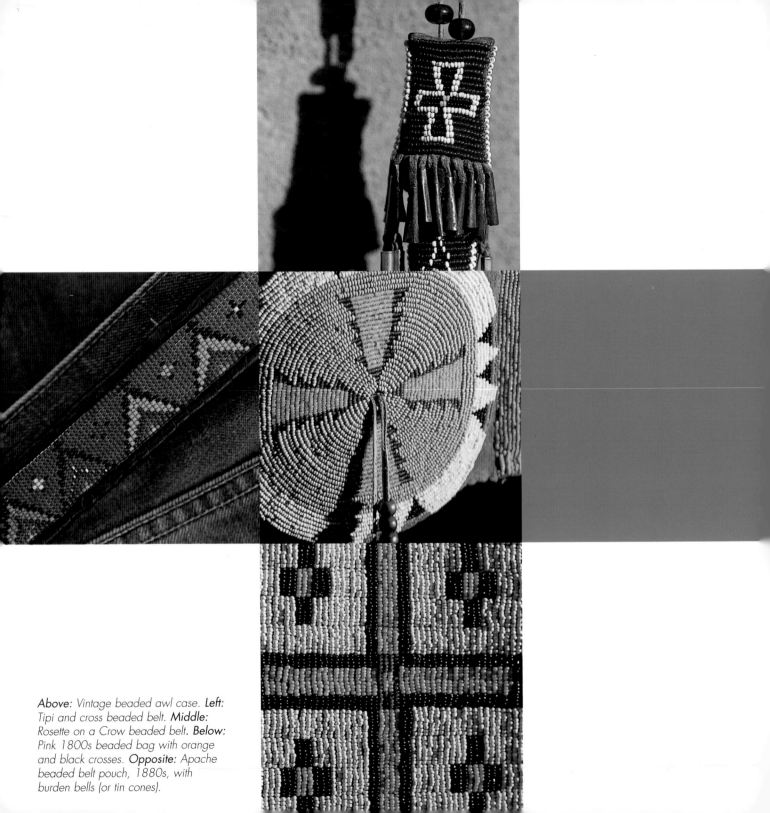

Above: Vintage beaded awl case. *Left:* Tipi and cross beaded belt. *Middle:* Rosette on a Crow beaded belt. *Below:* Pink 1800s beaded bag with orange and black crosses. *Opposite:* Apache beaded belt pouch, 1880s, with burden bells (or tin cones).

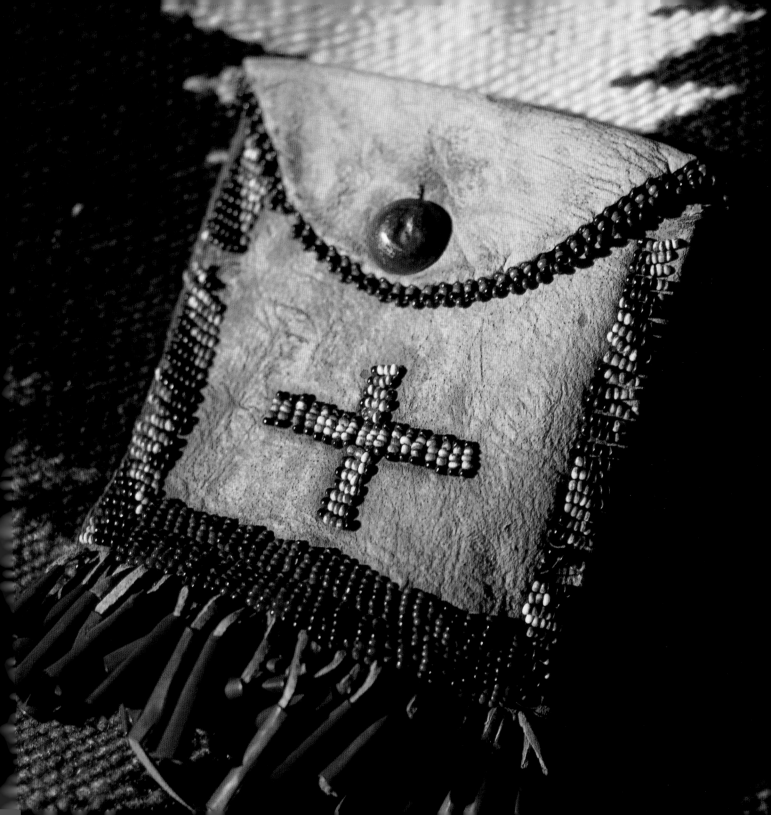

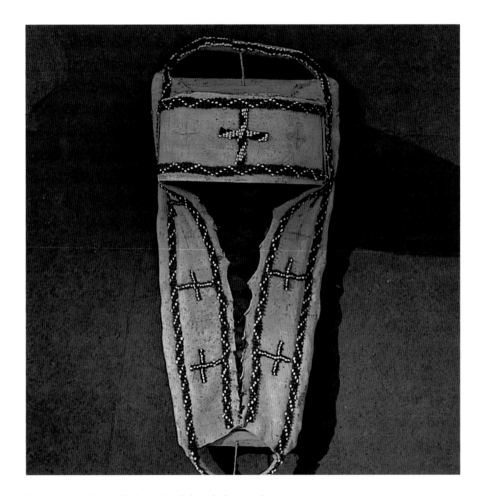

Vintage Apache cradle board with beaded cross design.

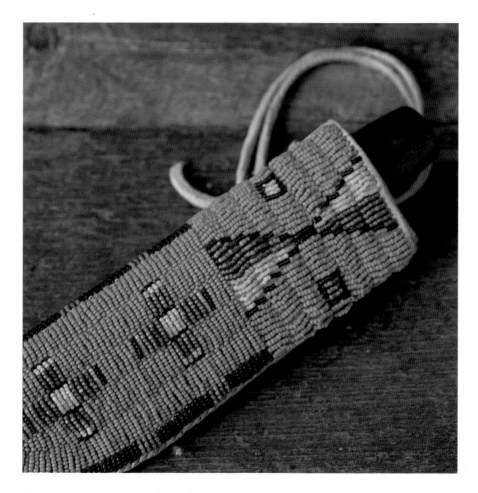

Contemporary (1970s) beaded knife sheath.

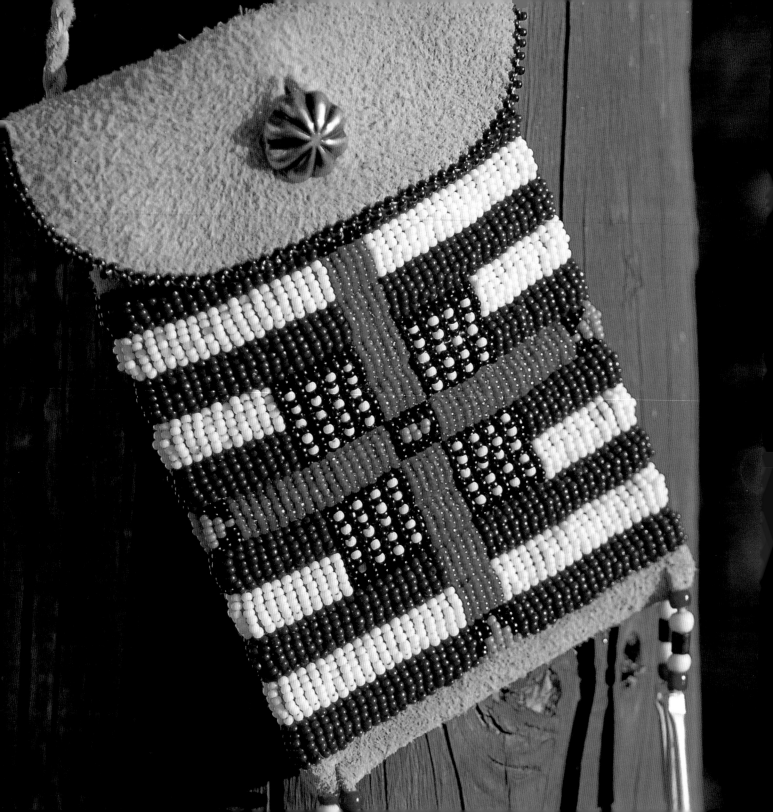

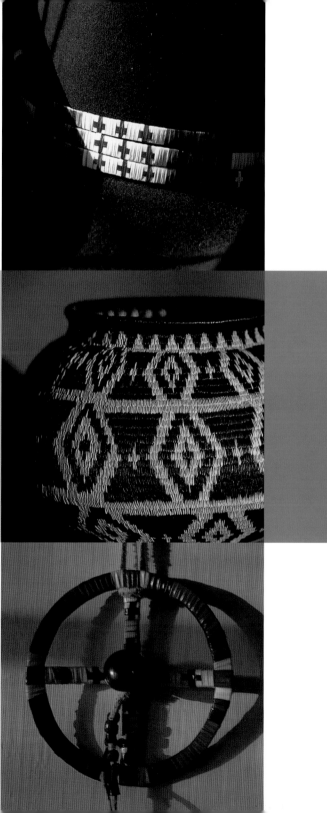

Opposite: Contemporary Native belt pouch with flag-cross design. ***Above:*** Contemporary three-row quill hat band with red crosses on a black cowboy hat. ***Middle:*** Black and beige Peruvian olla. ***Below:*** Traditional porcupine-quill medicine wheel.

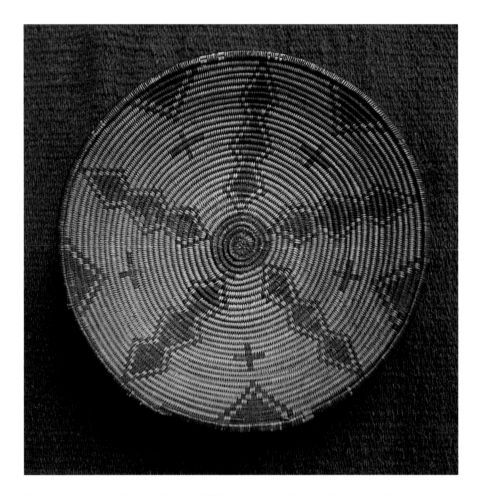

Above: Vintage Apache tray basket, 1920s. **Opposite:** Vintage Pima coiled basket with running crosses.

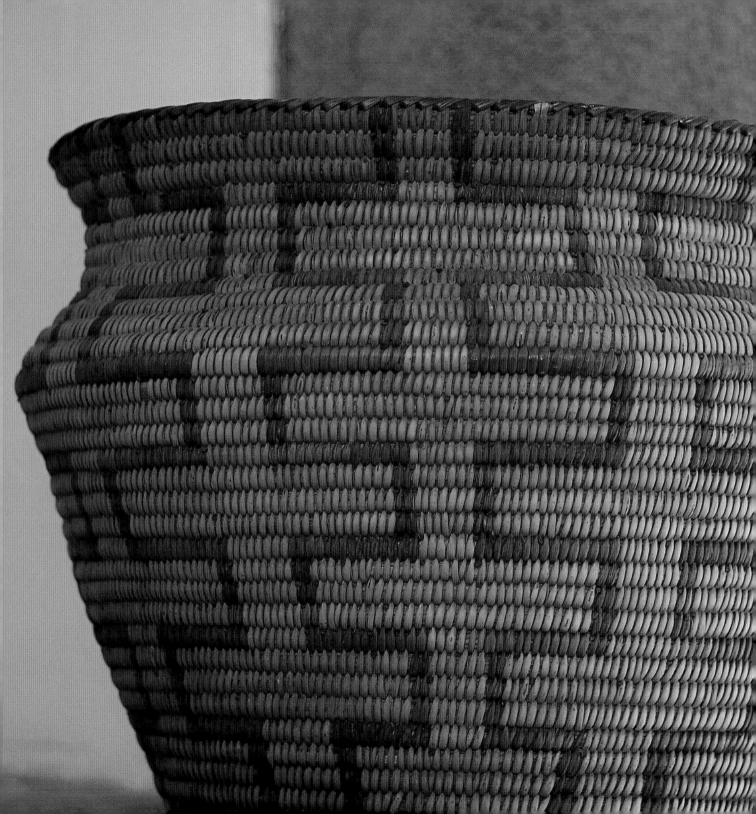

TEXTILES

♦ ♦ ♦ ♦ ♦

IN THE 1870S, renowned trading post owner J. L. Hubbell drew designs he felt would have considerable appeal for Anglo buyers. Inspired by Persian designs, they were quickly adopted by the skilled Navajo weavers and are highly prized by collectors worldwide.

Other strong cross influences were attributed to copying Plains Indian beadwork designs, blanket strips and the famous Ghost Dance shirts.

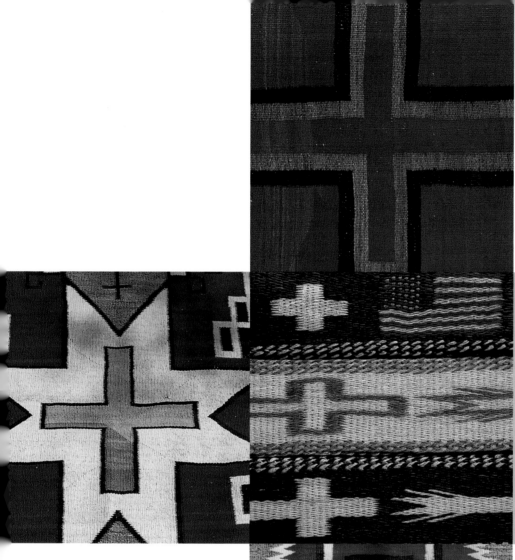

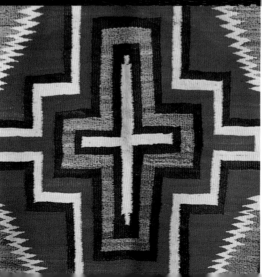

Above: 1930s Navajo blanket, red cross outlined with gray and black. *Left:* 1940s Navajo blanket in tan, black and ivory, featuring a large cross in the center. *Middle:* Three contemporary horsehair hitched belts. *Below:* Navajo rug, ca. 1900, with nested cross designs.

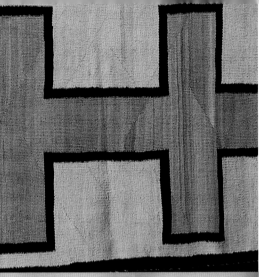

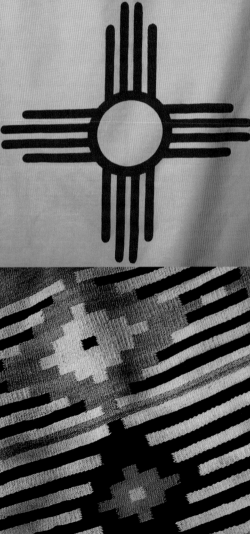

Above: Detail of Navajo textile cross in all natural wool. *Middle:* zia design, the basis for the New Mexican State flag. *Below:* 1930s Navajo weaving in tan, black, ivory and orange with multiple crosses. *Opposite:* Navajo rug, ca. 1920s , in hand-spun wool yarns in black, white, red and beige.

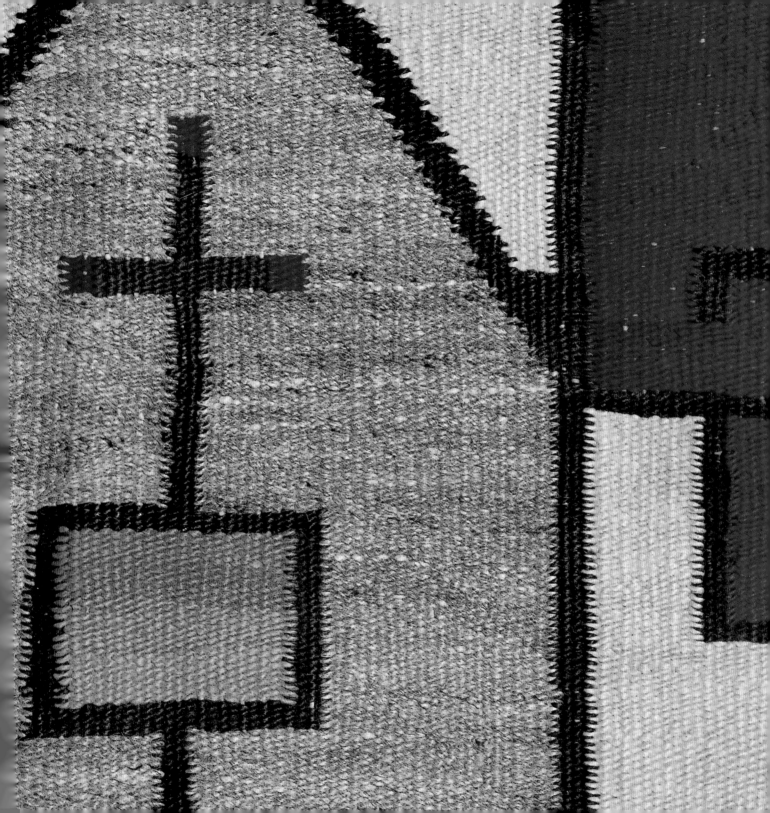

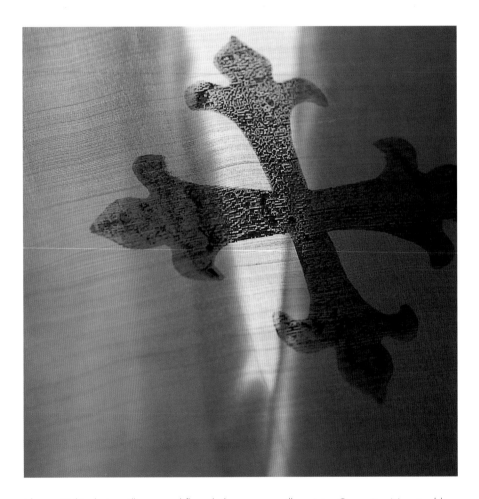

Above: Celtic-design silk-screened fleur de lys cross on silk curtain. **Opposite:** *Navajo blanket, 1920s, with gray background and multiple beige crosses outlined in black.*

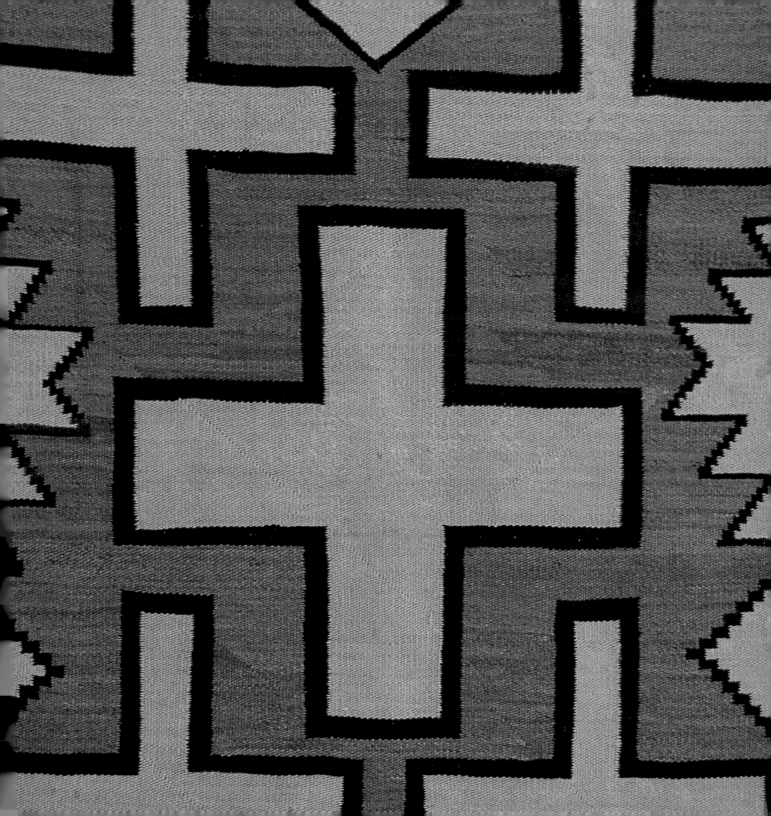

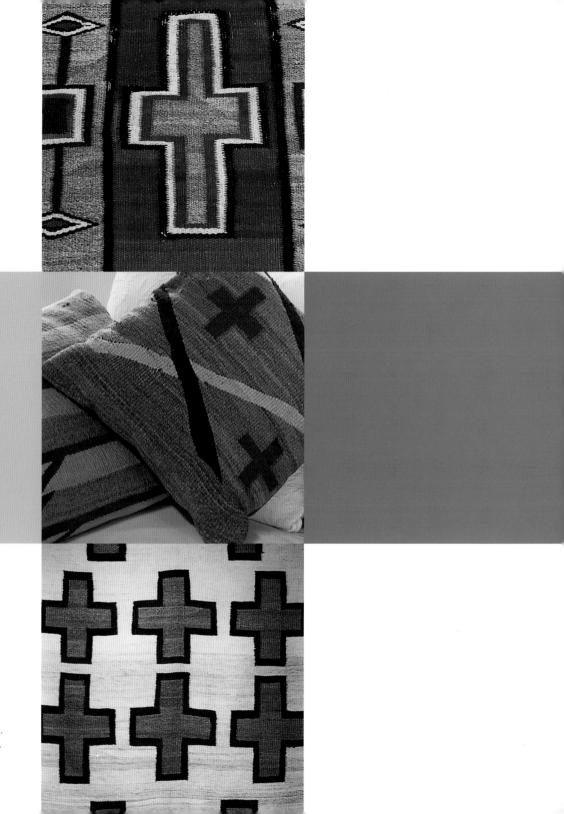

Opposite: A 1920s Navajo weaving blanket with cross accents. ***Above:*** Vintage Navajo rug with cross design in red, black and natural white, 1900s. ***Middle:*** Navajo rug made into pillows. ***Below:*** Multiple brown crosses on a 1930s Navajo weaving.

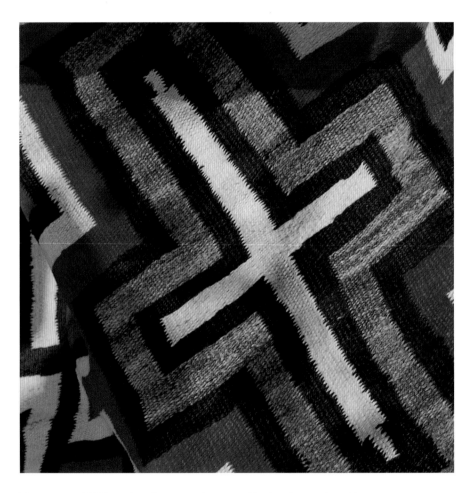

Navajo rug, 1920s, in hand-spun wool yarns in black, white, red and beige.

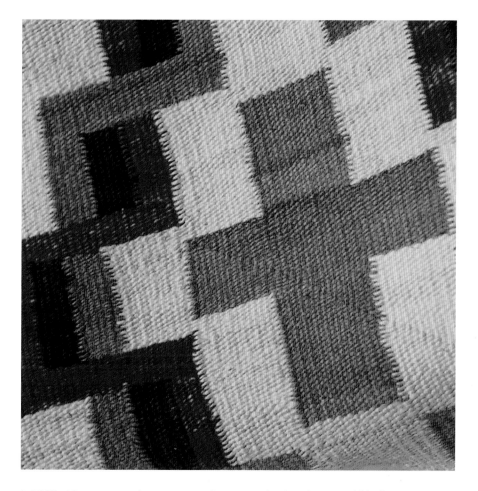

A 1920s Navajo rug with center cross design in red, white, beige and black.

LEATHERWORK

❖ ❖ ❖ ❖ ❖

ANIMAL SKINS FROM the beginning of time lent themselves well for clothing and shelter. And with that, adornment from painting, cutting and carving began. Native and Hispanic cultures and, later, cowboys of the American West all used crosses and variations of cross designs to individualize their leather items.

Following are extraordinary examples of leather pieces featuring crosses in all manner of diverse designs.

Contemporary sterling silver buckle set with cross on russet hand-tooled leather holster.

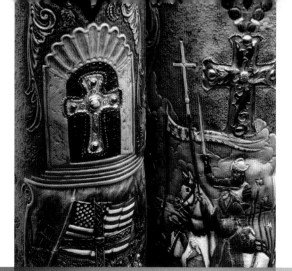

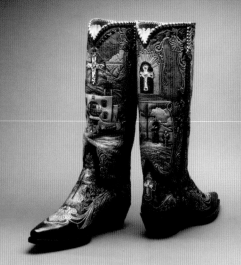

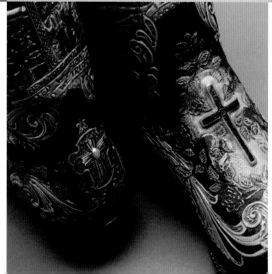

Above: Silver crosses adorn the top and heel of this pair of deeply carved cowboy boots. Every angle reveals a silver or tooled cross.

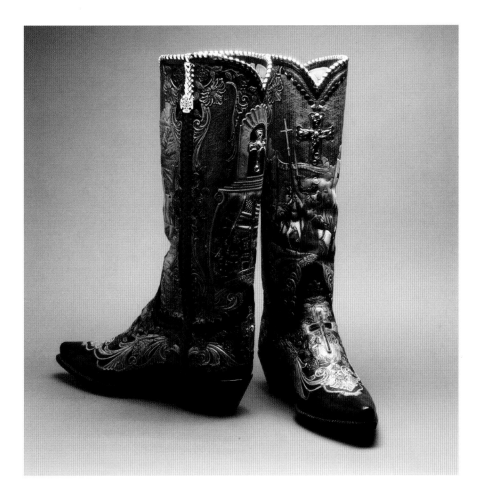

*Ornately tooled and painted man's cowboy boots feature crosses as part of the story.
Boot by Tres Outlaws.*

Rawhide-fringed belt bag with blue painted cross.

Nez Pierce parfleche saddle bag with cross, 1880s.

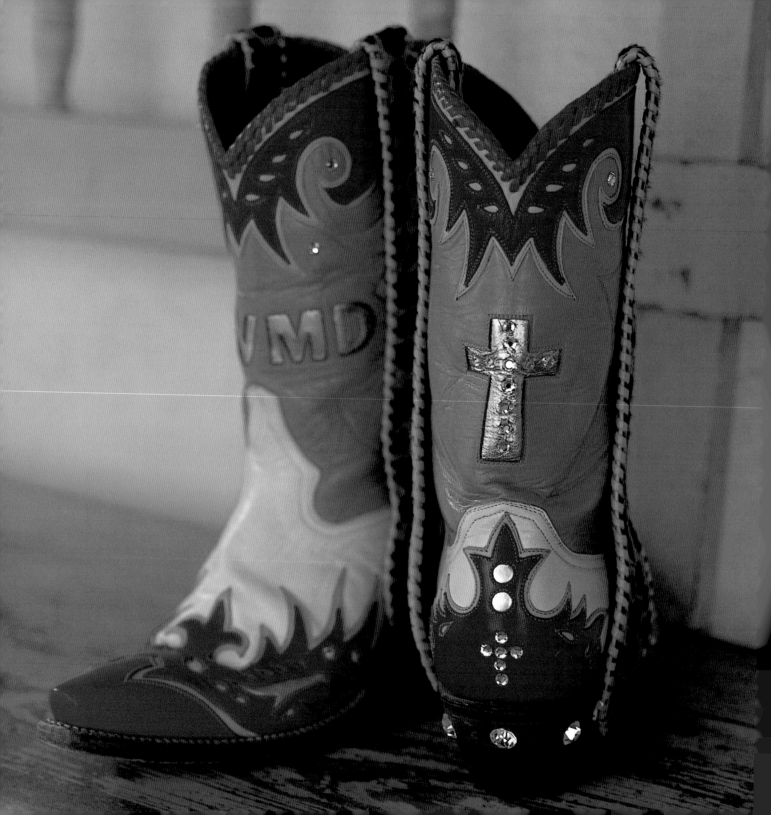

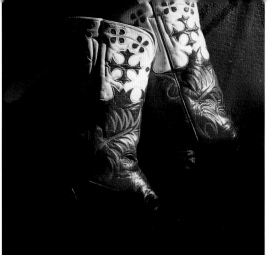

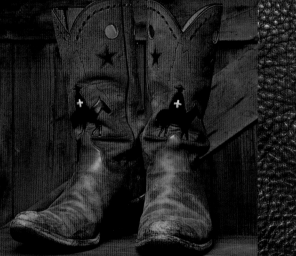

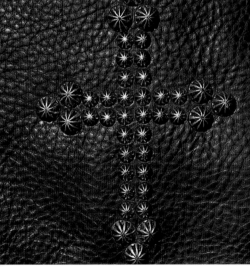

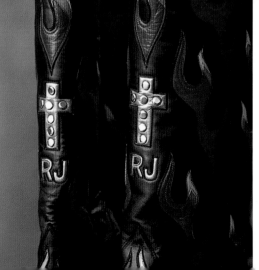

Opposite: Rocketbuster custom boots with Swarovski crystals. **Above:** *Vintage cowboy boots in white, red and black with red crosses.* **Middle:** *Silhouette of a padre (identified by the cross) on his horse. From a Navajo pictograph drawing at Canyon de Chelly.* **Right:** *Metal studs make a cross design on a leather purse.* **Below:** *Hand-cut flames and silver leather crosses with studs, by Rocketbuster Boots.*

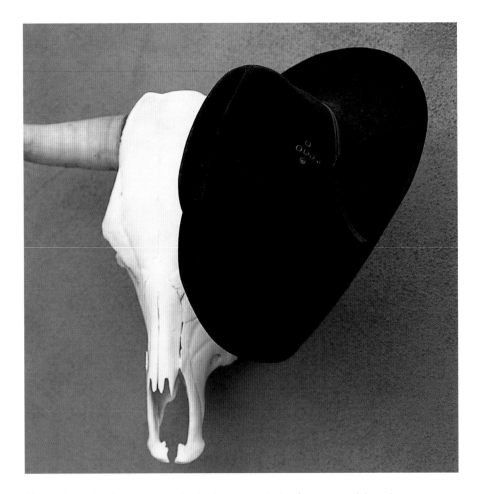

Above: A cowboy's accessory to his leather gear. His hat features a subtle red grommet cross venting the crown. *Opposite:* A collection of Dave Little cowboy boots with crosses inside crosses—in the zia style.

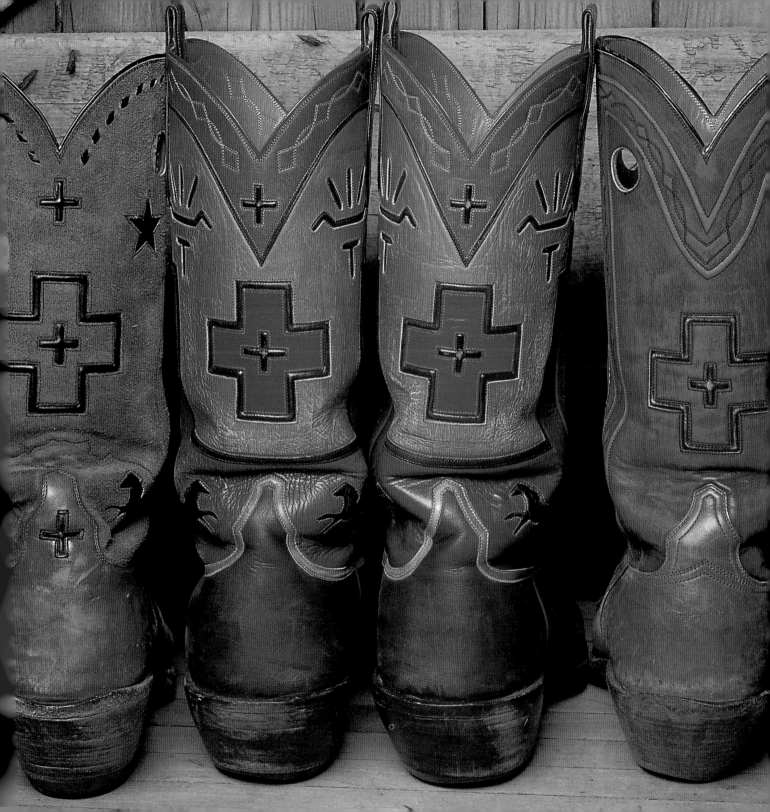

CANDLE HOLDERS
AND
DECOR

◆ ◆ ◆ ◆ ◆

MANY CHRISTIAN HOMES worldwide have personally created islands, nichos, mantels, cupboards and tabletop displays of their devotion to their religion.

Most have a cross or collections of crosses and icons in one form or another, in most instances integrated with candles. In many cases, they are truly miniature places of worship while in others they blend with the decor of their surroundings. Yet, when viewed, their power and lasting beauty become personal reminders of the owners' individual religious beliefs.

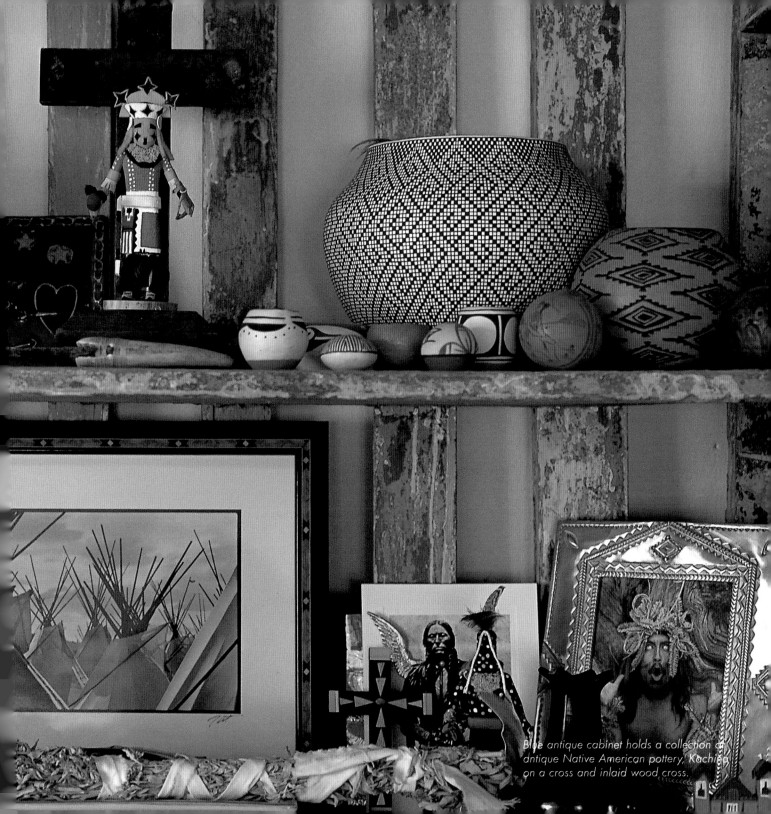

Blue antique cabinet holds a collection of antique Native American pottery, Kachina on a cross and inlaid wood cross.

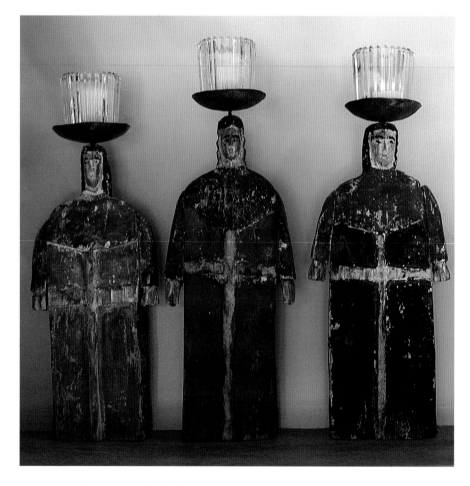

Antique wooden priest candle holders.

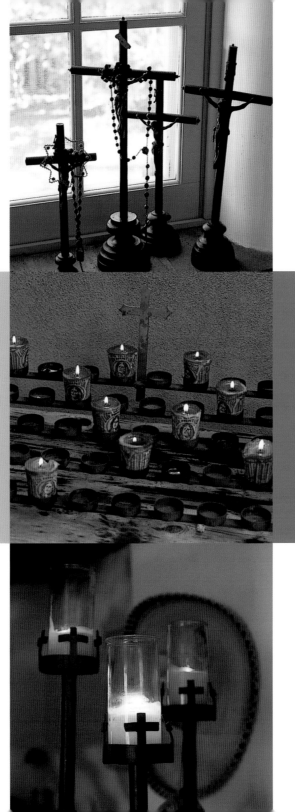

Above: Collection of black European crucifixes with rosaries wrapped around them. *Middle:* Antique church votive offering stand in iron. *Below:* Spanish-influenced church candelabras with iron crosses holding glass votives.

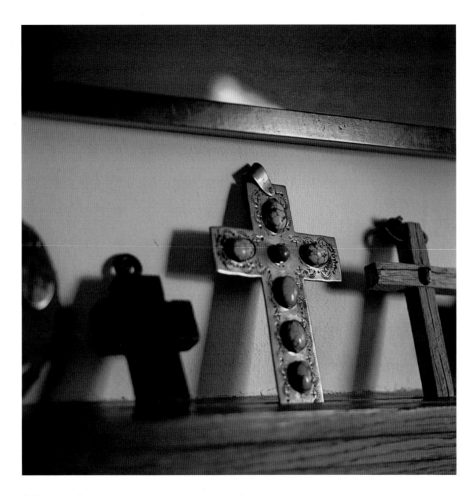

Collection of contemporary crosses on a mantel.

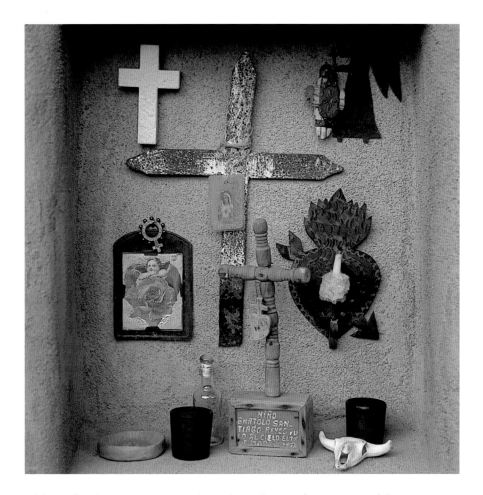

Adobe wall niche in a Santa Fe garden with a collection of contemporary folk art crosses made by young artists and purchased at Spanish Market.

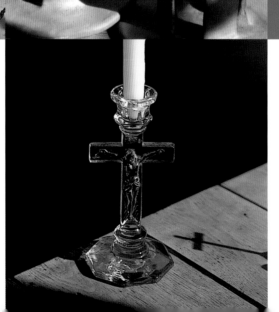

Above: Contemporary black iron candlesticks. *Left:* Mexican brass crowns with crosses. *Middle:* Pueblo terra-cotta candlesticks with painted black crosses. *Below:* Antique glass crucifix candle holder. *Opposite:* Modern German silver wall cross candlestick with three rings.

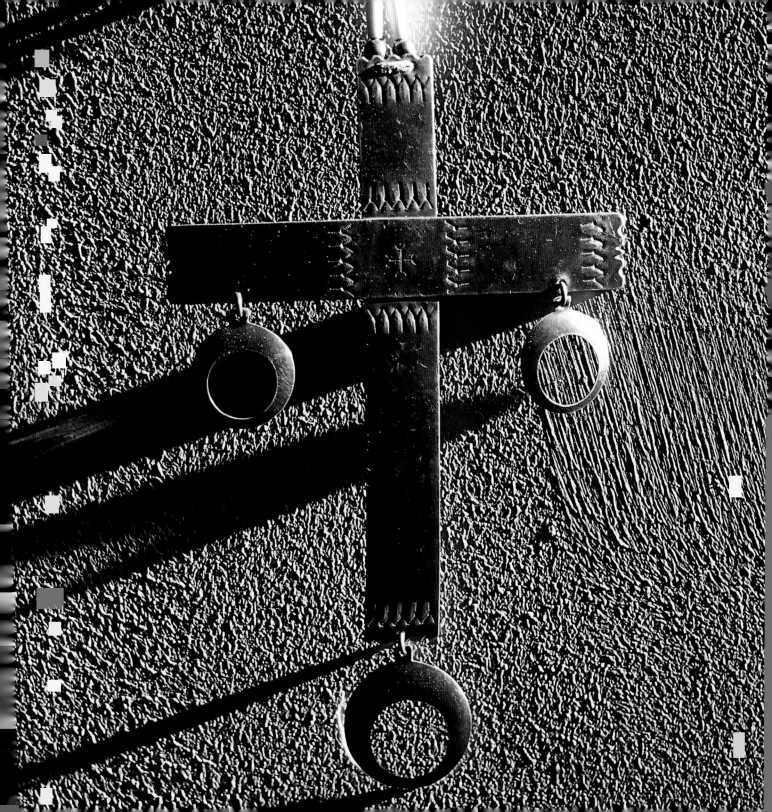

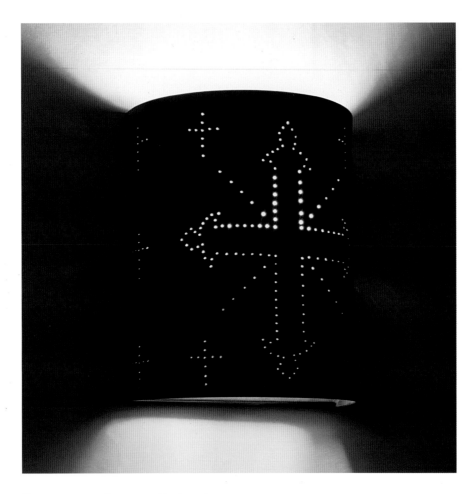

Contemporary wall sconce with pierced cross.

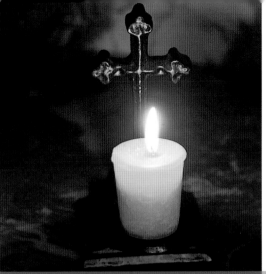

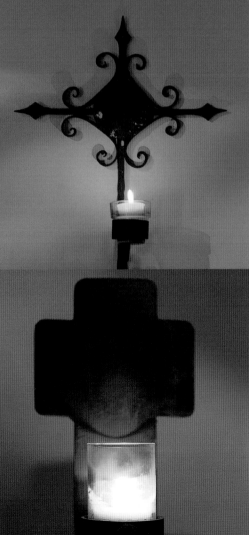

Above: Modern cast-iron stand accented by a votive candle. *Middle:* Antique iron wall sconce with votive candle holder. *Below:* Contemporary iron-cross votive wall hanging.

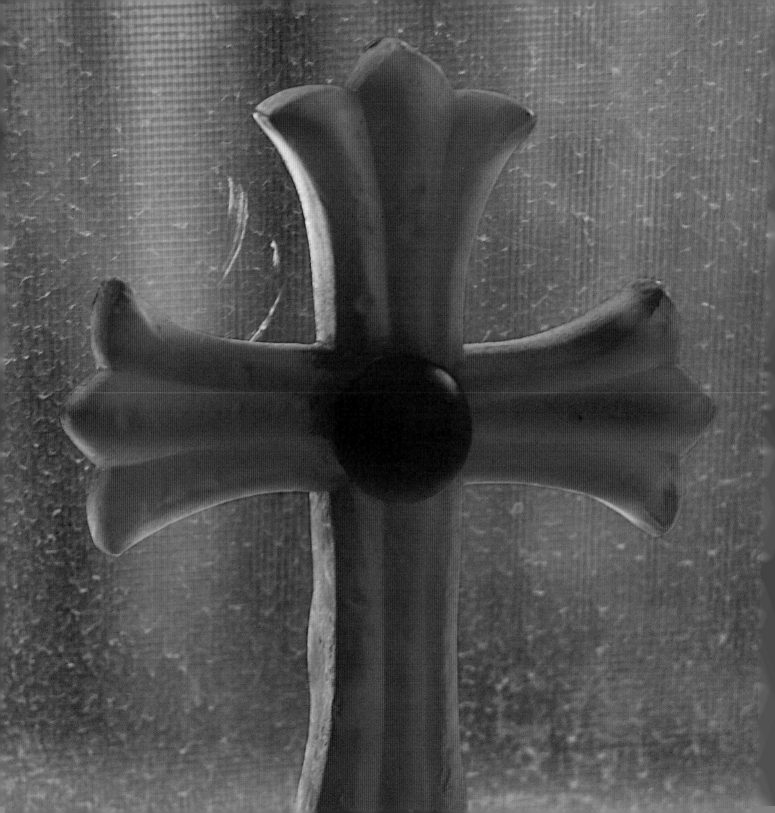

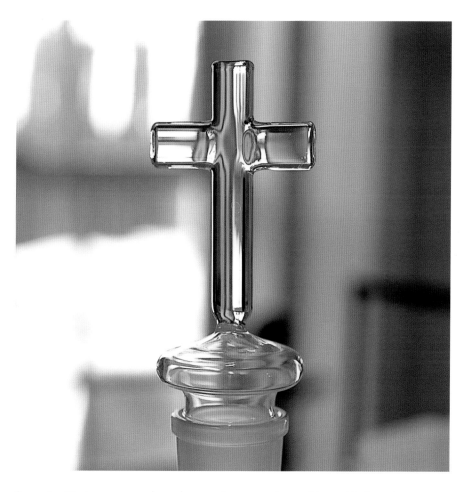

Opposite: Contemporary amber-color soap in a cross shape. *Above:* Modern glass cross stopper on a wine decanter.

RELIGIOUS ICONOGRAPHY

◆ ◆ ◆ ◆ ◆

ICONOGRAPHY USUALLY refers to the design, creation and interpretation of symbolism within religious art. The word literally means "image writing." Icons are used by many religions, including Hinduism, Buddhism and Christianity.

In the year 1787 at the seventh ecumenical council held in Nicaea, the iconodules upheld the use of icons as an integral part of Christian tradition. It was said that the praise shown to an icon passes over to the archetype. Thus to kiss an icon of Christ was to show love towards Christ Jesus himself and not the wood, paint or silver making up the physical icon.

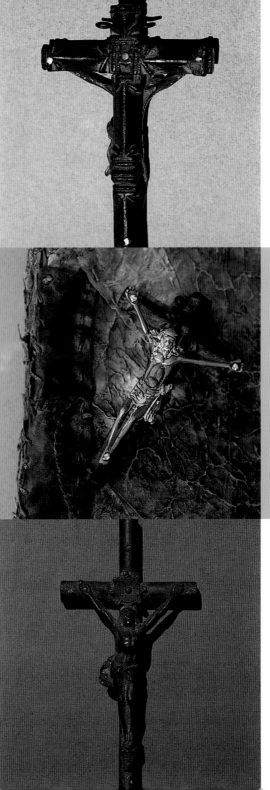

Above: French iron antique cross, 1800s. *Middle:* Antique crucifix on an old Bible. *Left:* Collection of 1940s brass and tin heart milagros wrapped with a vintage wooden rosary. *Below:* Iron cross crucifix, 1910, on a pink adobe wall.

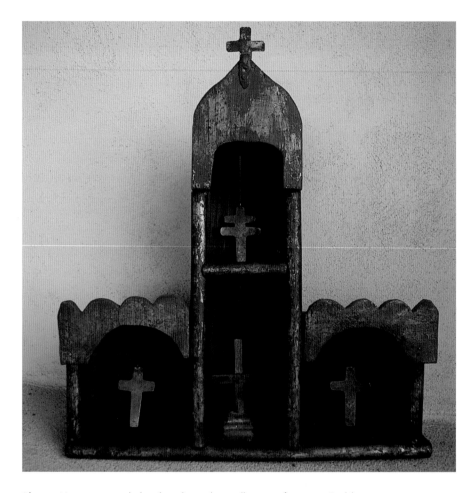

Above: Hanging wood church nicho with a collection of antique Pueblo crosses.
Opposite: Wood cherub on stand with brass crown and gold cross necklace.

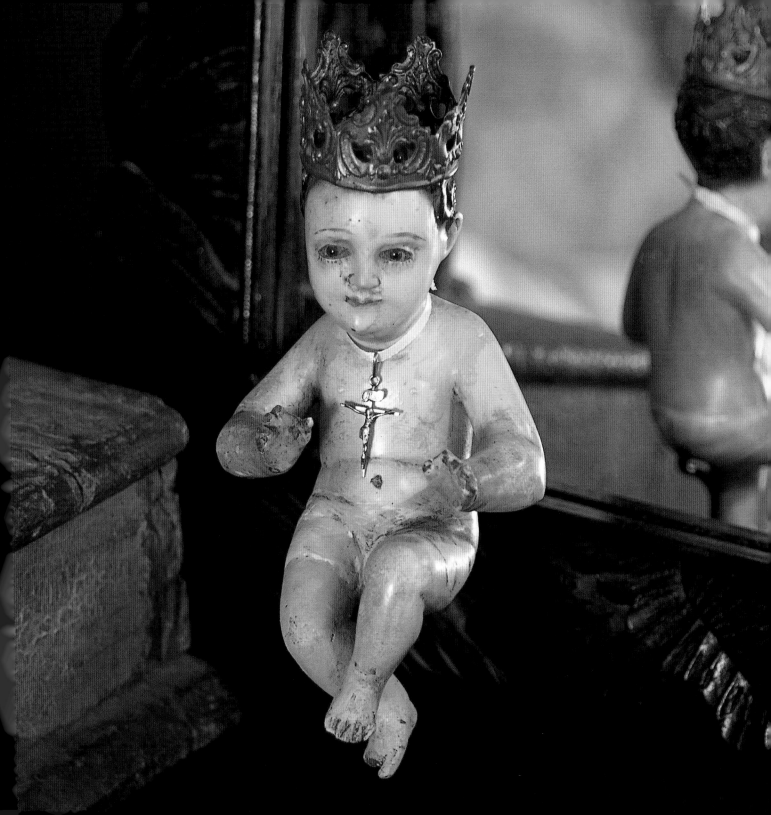

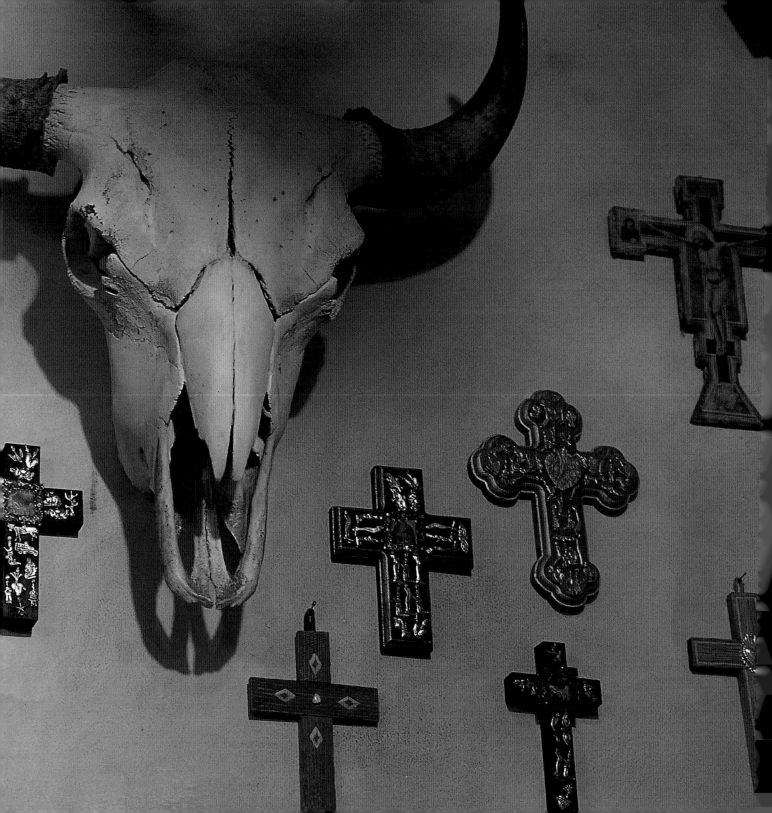

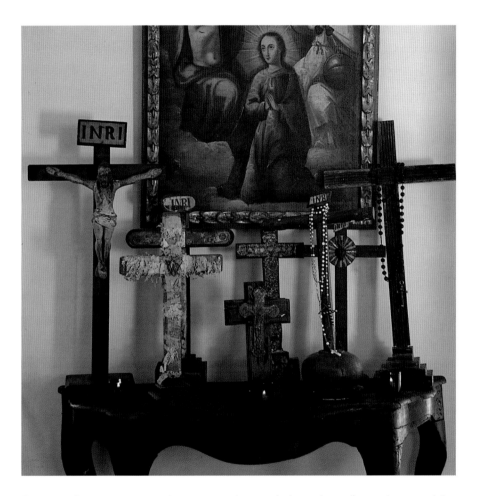

Opposite: Contemporary wooden crosses with tin and silver milagros featured on an adobe wall. *Above:* Collection of antique American and Mexican crosses embellished with milagros, rosaries and hearts.

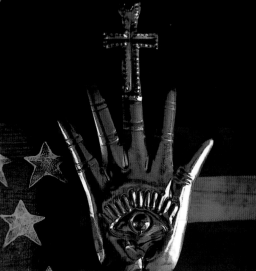

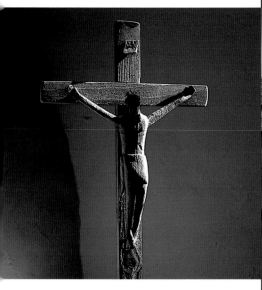

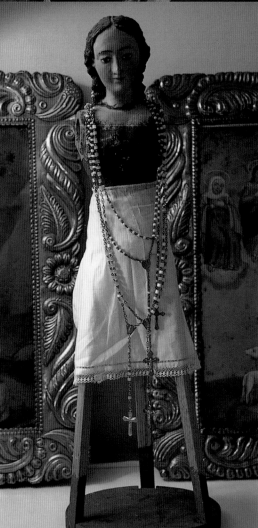

Above: Contemporary Spanish folk art tin hand with a cross featured on the finger. **Middle:** *Wooden saint with antique white skirt and children's beaded rosaries.* **Left:** *Antique natural wood crucifix.* **Opposite:** *Antique brass milagros wrapped with multicolored glass-bead rosary and brass crucifix.*

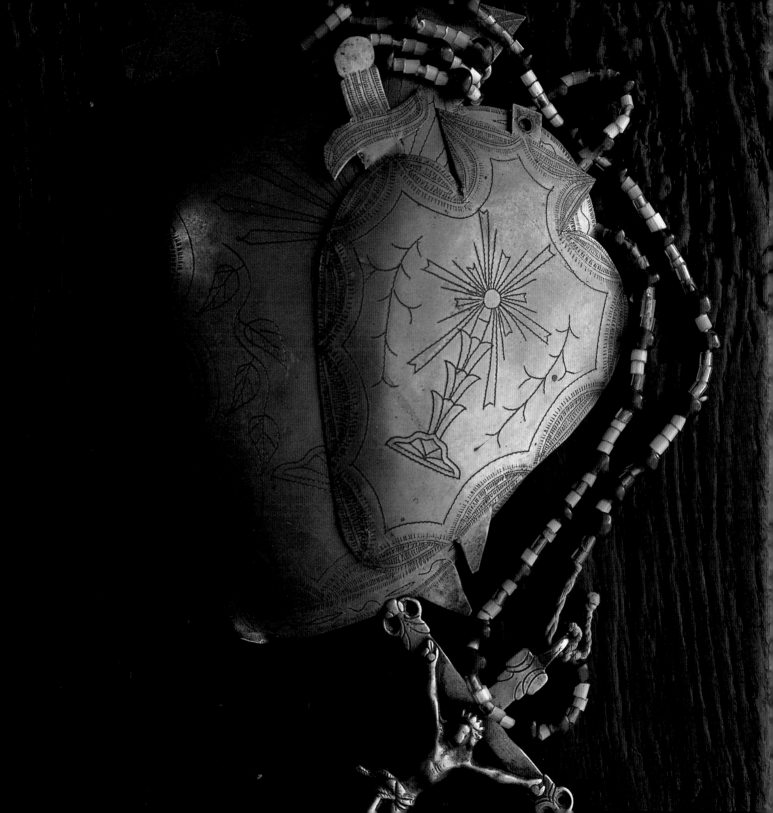

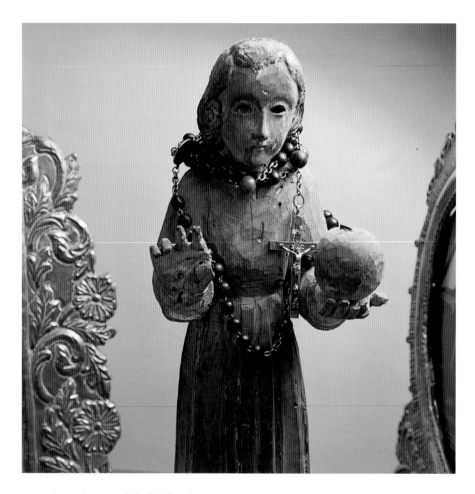

Natural-wood saint with ball in hand, wearing an antique rosary.

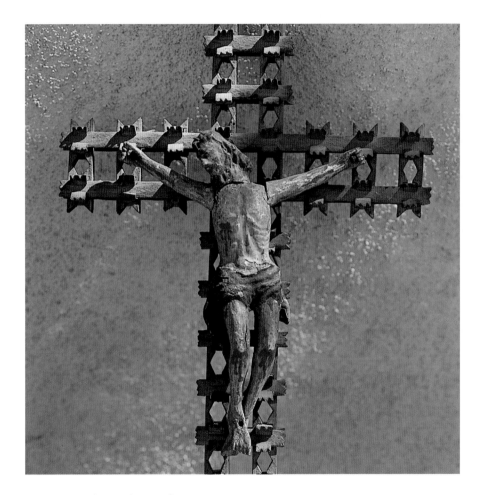

Antique Spanish wooden crucifix.

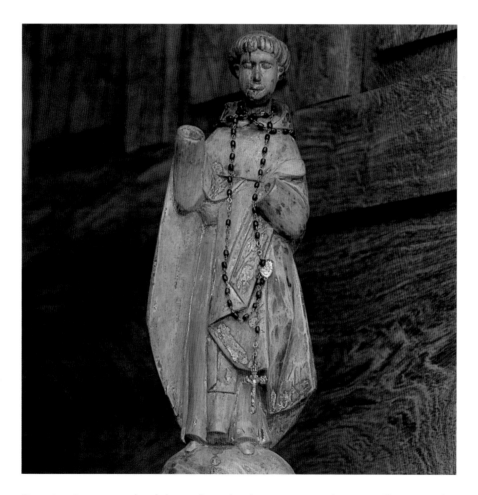

Opposite: Antique metal-and-glass nicho with milagros on a wooden cross. **Above:** Hand-carved saint on a ball stand, ca. 1890, enhanced with a brown wooden rosary about his neck.

JEWELRY

◆ ◆ ◆ ◆ ◆

CROSSES IN JEWELRY are found universally, but in
these beautiful photographs you will see their history, from
dragonfly crosses, sand casts and filigrees to silver, gold
and semiprecious and precious stones. The Spaniards
brought their crosses to the North American Southwest in the
1600s. The priests introduced them to the Pueblos, Navajos
and Apaches. Many of the early imported crosses were
made of copper, and later silver became the most popular
material. The wonder of these crosses is in their diversity,
and each is beautiful in its own way.

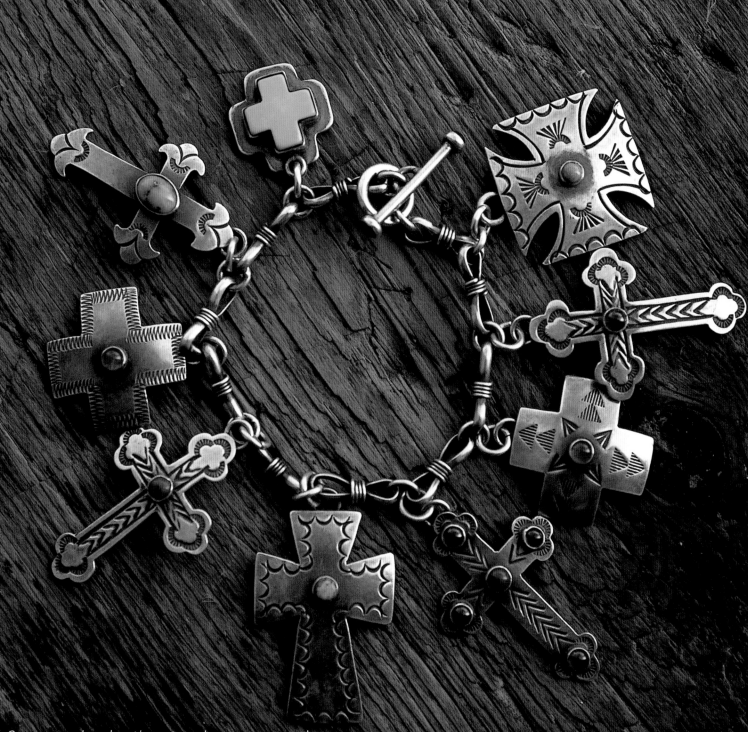

Contemporary bracelet with crosses and precious stones in design.

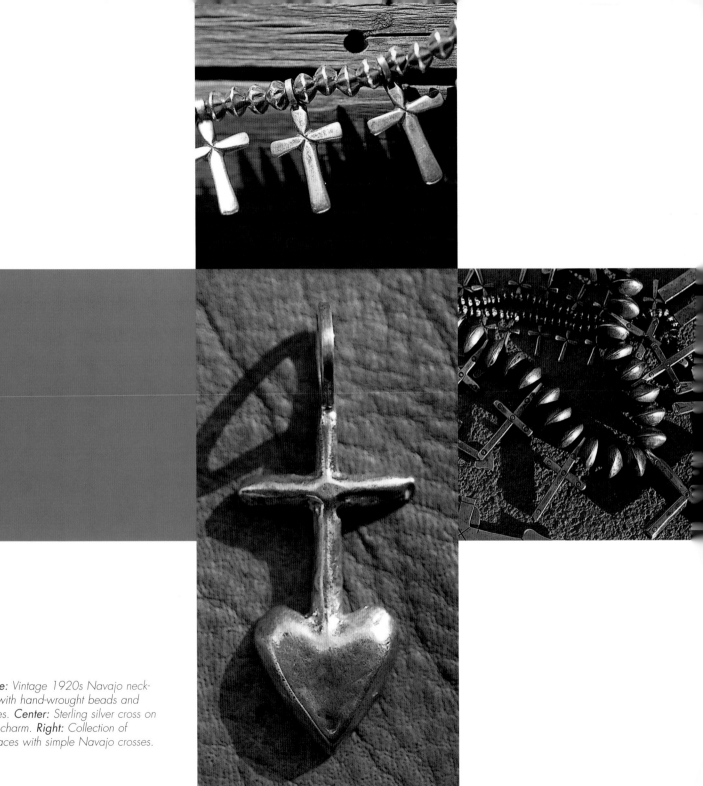

Above: Vintage 1920s Navajo necklace with hand-wrought beads and crosses. *Center:* Sterling silver cross on heart charm. *Right:* Collection of necklaces with simple Navajo crosses.

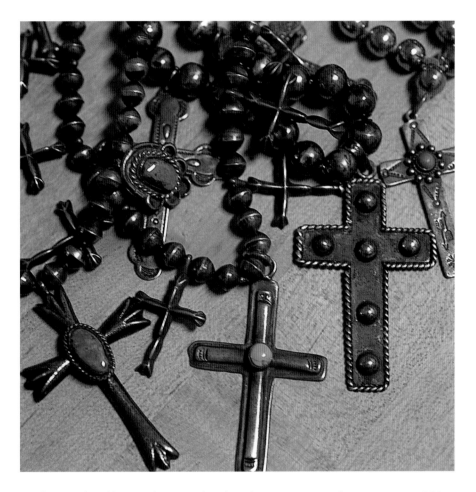

A collection of necklaces with Navajo beads and crosses, some with turquoise, ca. 1930s.

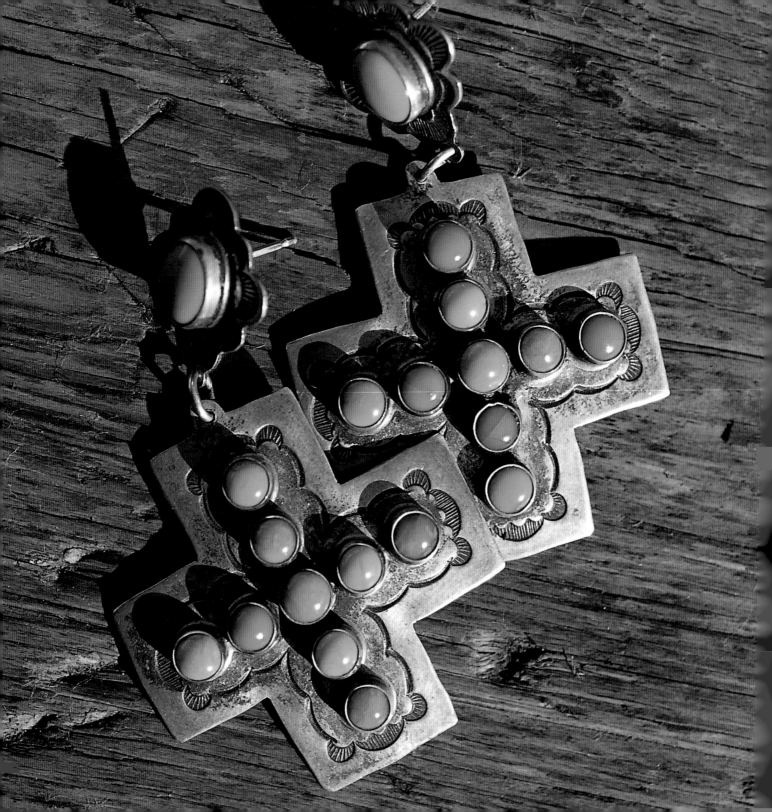

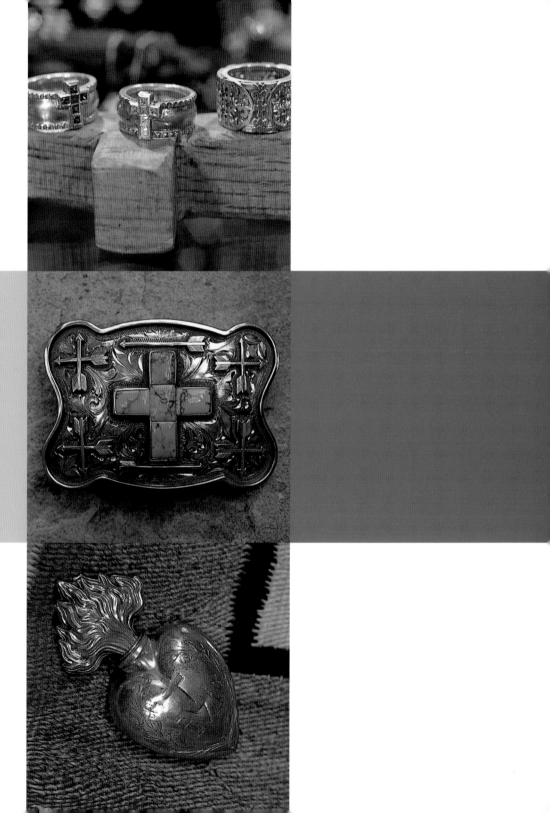

Opposite: Modern silver cross earrings with turquoise stones. *Above:* Loree Rodkin rings with diamonds and semi-precious stones in a cross design. *Middle:* Contemporary cross-inspired turquoise belt buckle engraved with sterling crosses. *Below:* Gold-gilded and domed French heart with etched cross design.

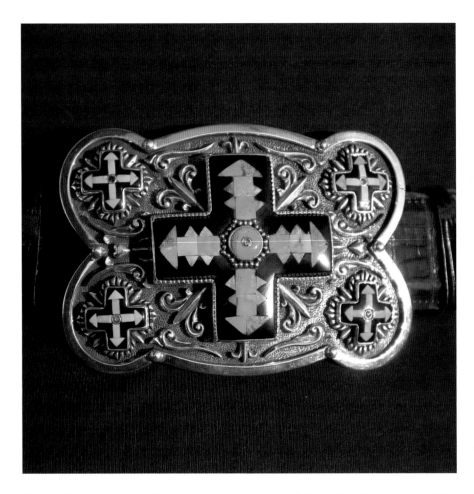

Above: *Modern turquoise, Russian jet and sterling silver belt buckle.* **Opposite:** *An 18k cross on sterling cuff with matching ring.*

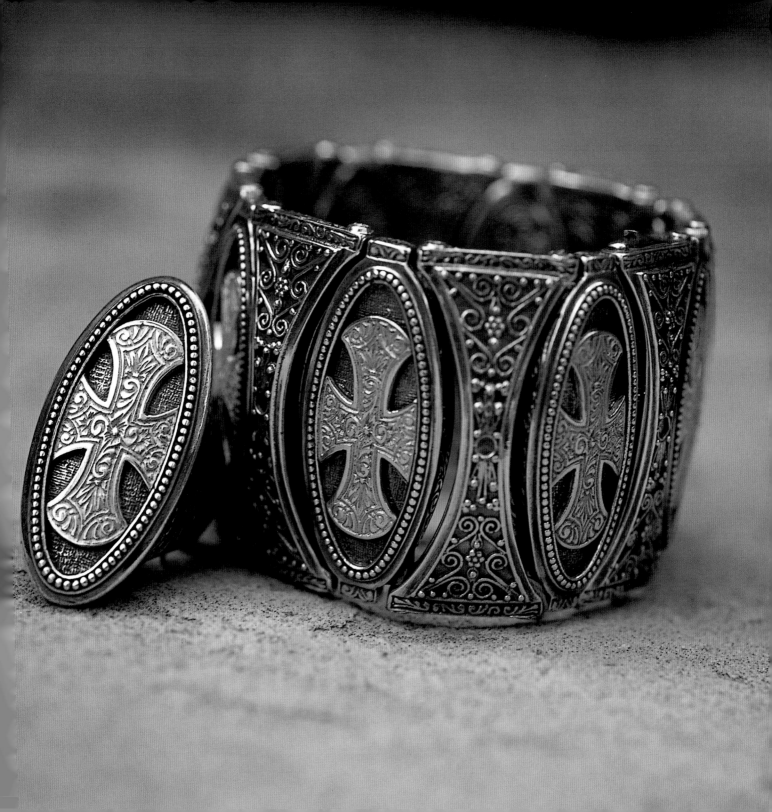

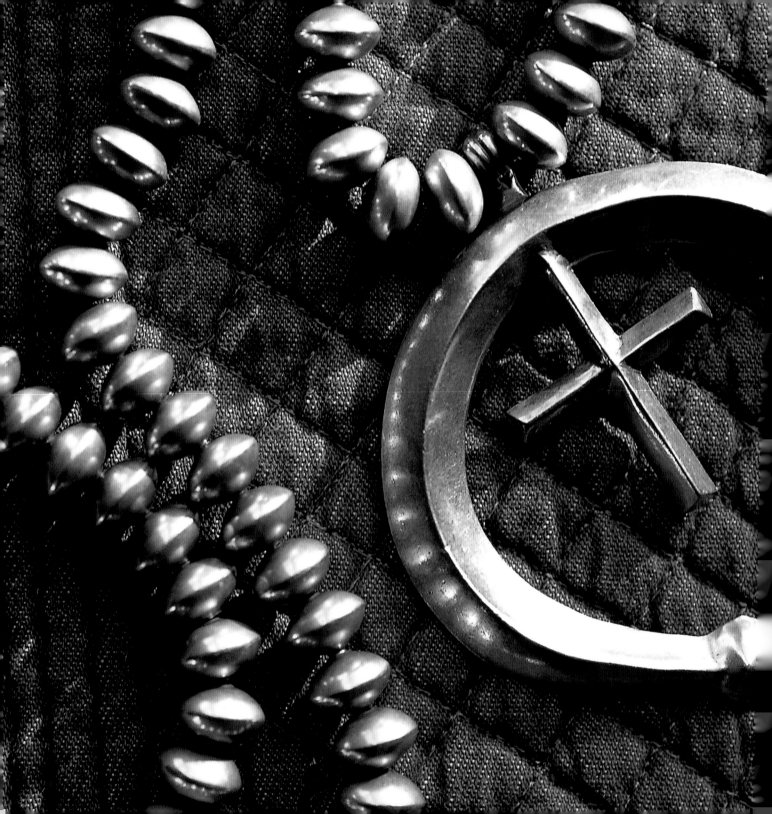

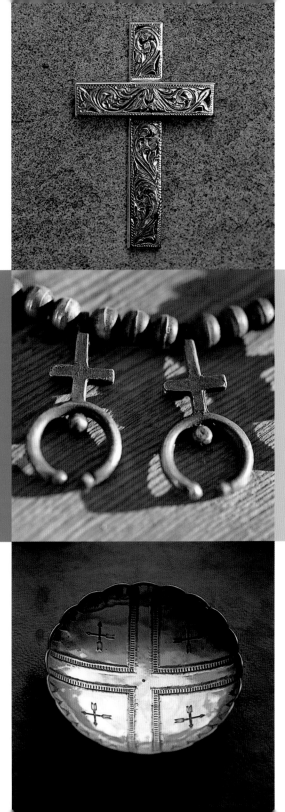

Opposite: Contemporary beads with cross in Naja. ***Above:*** Engraved pocket cross. ***Middle:*** Very old Navajo cross necklace in Naja design. ***Below:*** Round sterling silver bowl with large center cross.

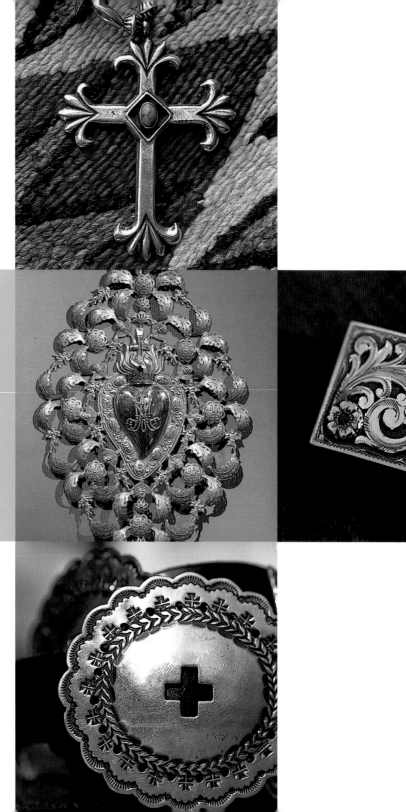

Above: Navajo cross pendant with turquoise. **Middle:** *Hanging French filigreed silver heart with cross on top.* **Right:** *Modern gold-on-silver belt buckle with cross in center.* **Below:** *Contemporary silver concho with cross in middle.*

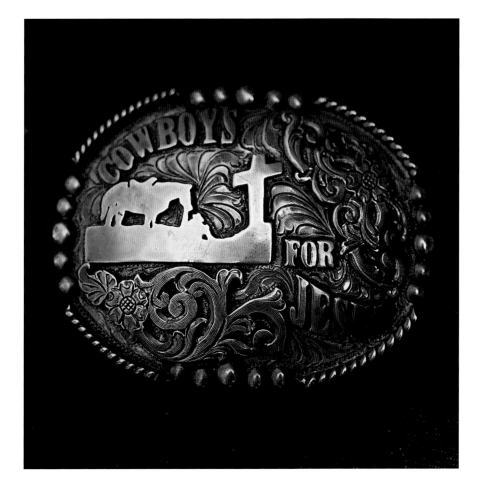

Contemporary sterling silver trophy buckle, "Cowboys for Jesus."

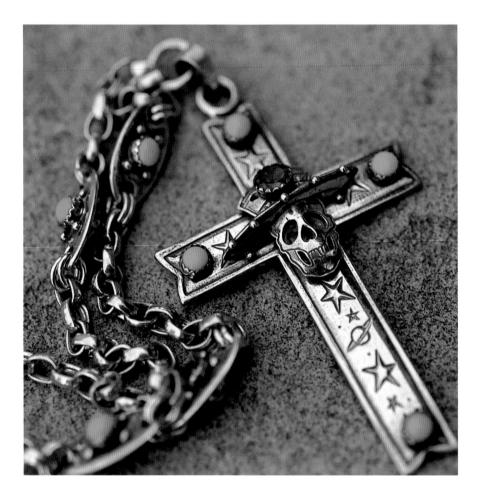

Above: *Modern Day of the Dead sterling silver cross necklace with turquoise.* **Opposite:** *Charm bracelet with crosses in sterling silver, rhinestones, enamel, diamonds, turquoise and rubies, ca. 1940s.*

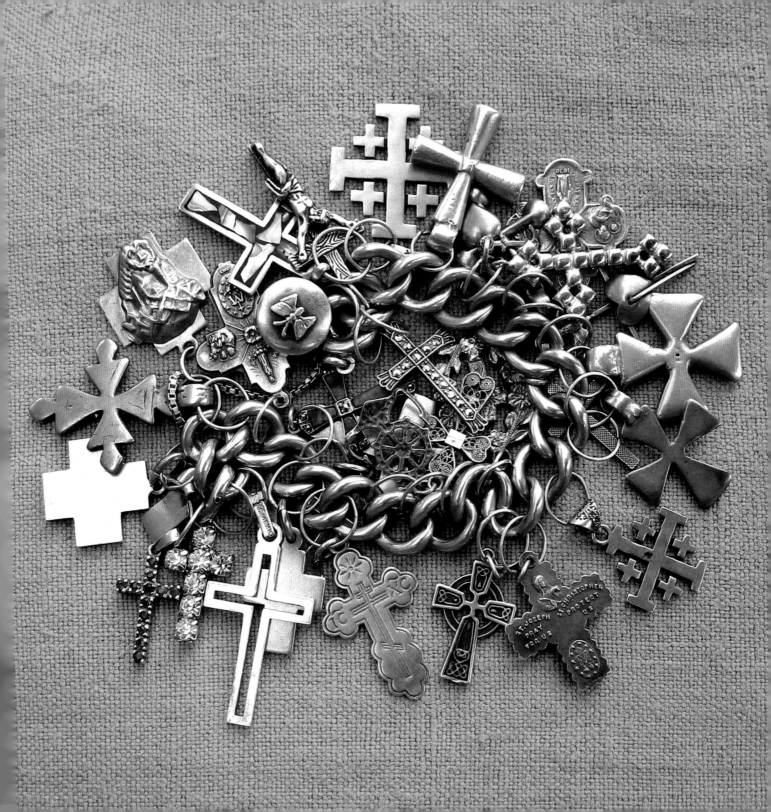

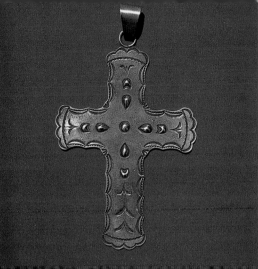

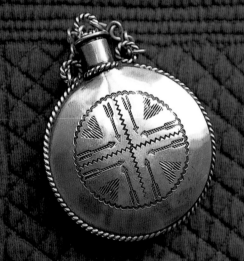

Above: Silver Navajo pendant cross with a simple design. *Left:* Modern silver cross necklace. *Middle:* Small silver canteen with cross design and arrow. *Below:* Pair of contemporary bow guard–styled bracelets, sterling silver on leather with turquoise. *Opposite:* Native-made dome silver beads with crosses and simple cross with turquoise.

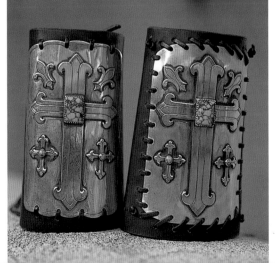

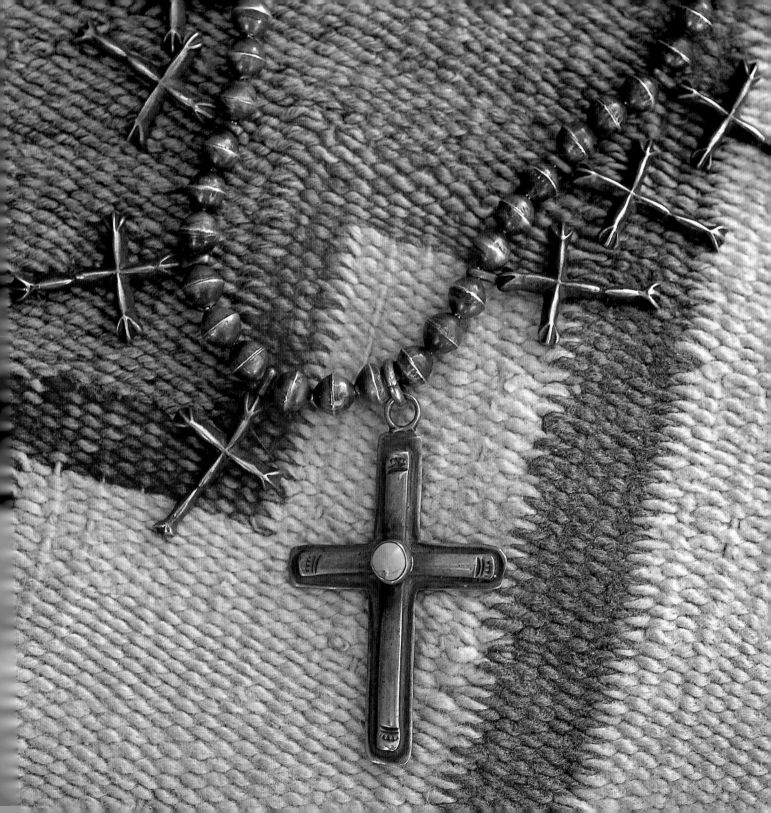

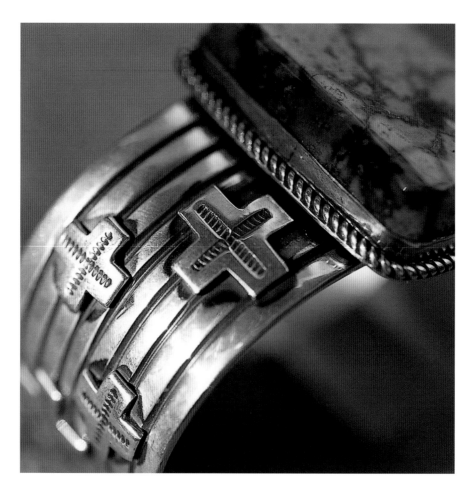

Contemporary heavy silver-and-turquoise bracelet.

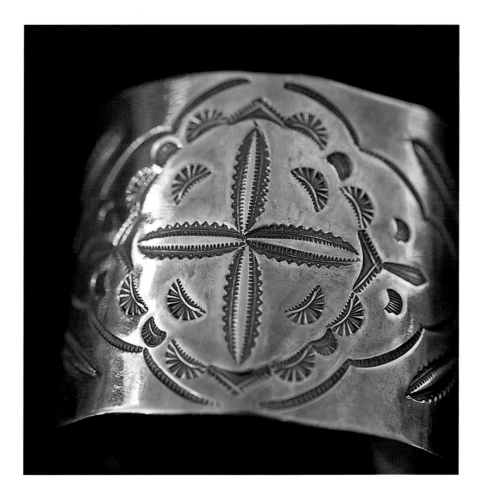

Vintage Navajo hand-stamped sterling silver cuff.

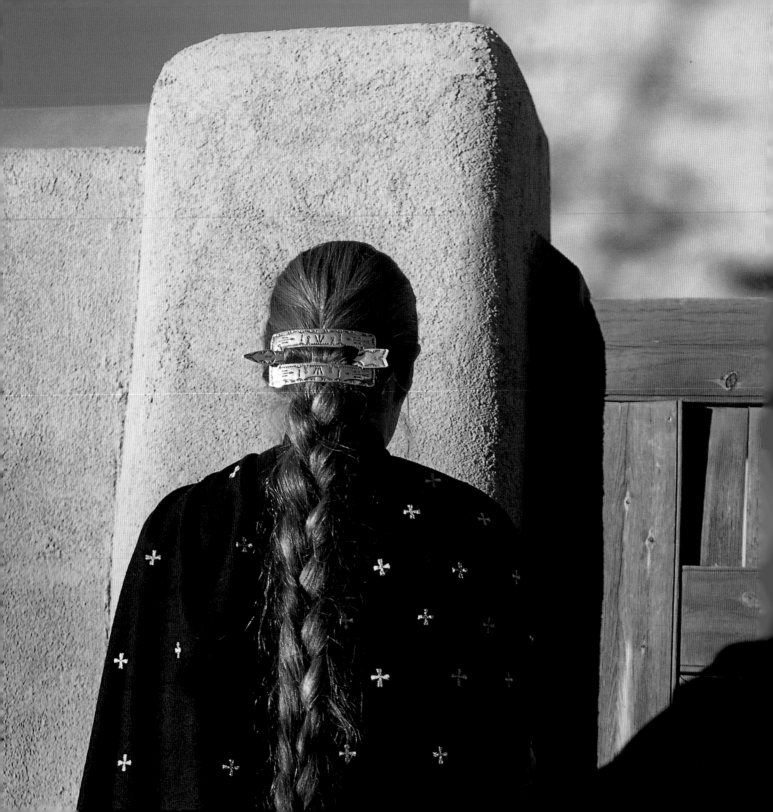

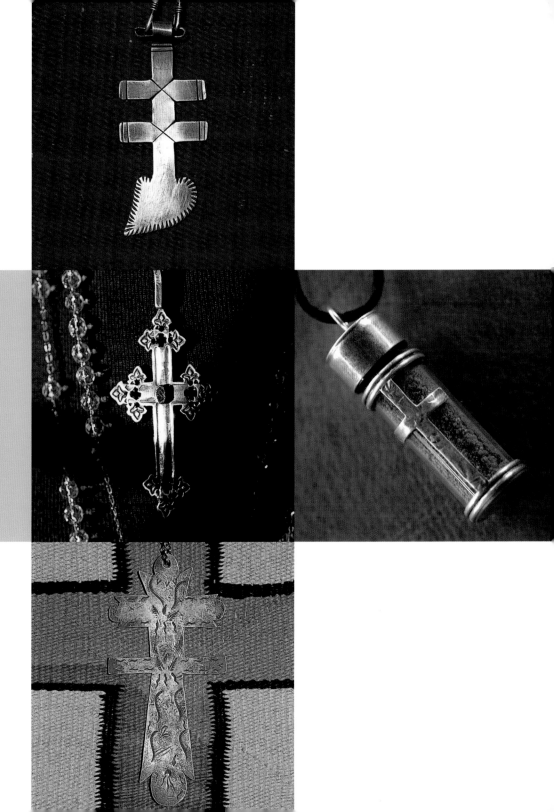

Opposite: Modern cashmere shawl with silver and gold crosses. *Above:* Double-barred silver cross pendant. *Middle:* Contemporary cross with semiprecious stones. *Right:* Silver cross on glass vial with healing dirt from Chimayo church; necklace. *Below:* Vintage double-barred trade silver cross pendant.

Above: Contemporary beaded cuff with yellow cross. **Opposite:** Modern turquoise neck-lace with free-form gold cross.

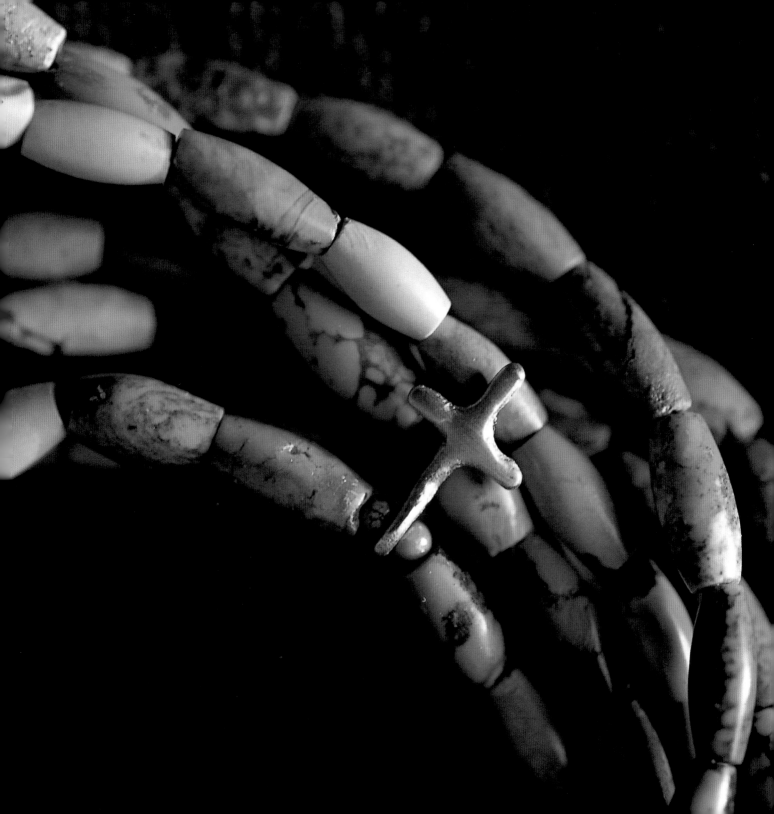

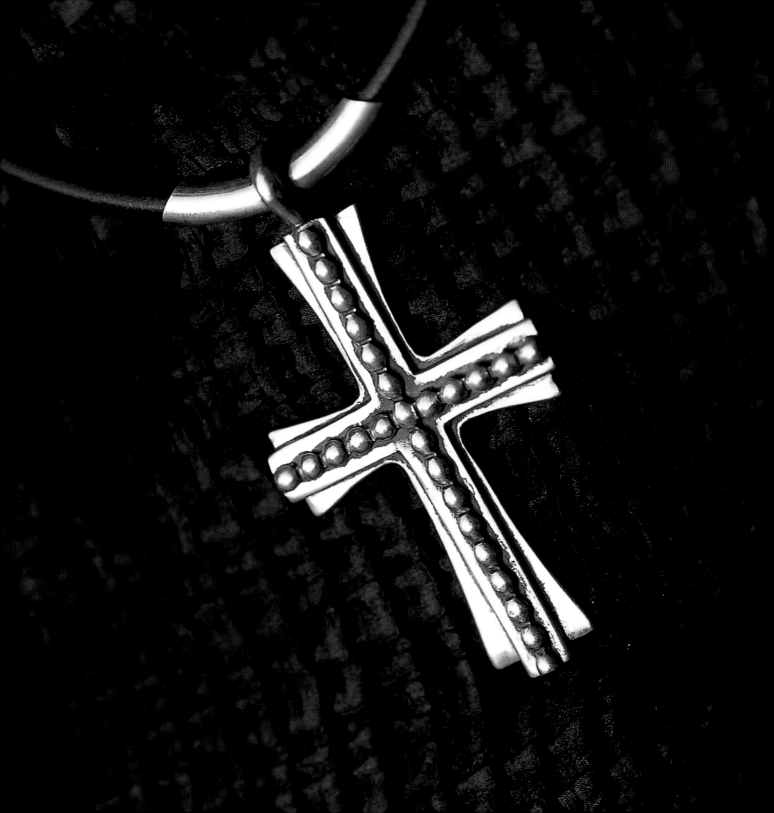

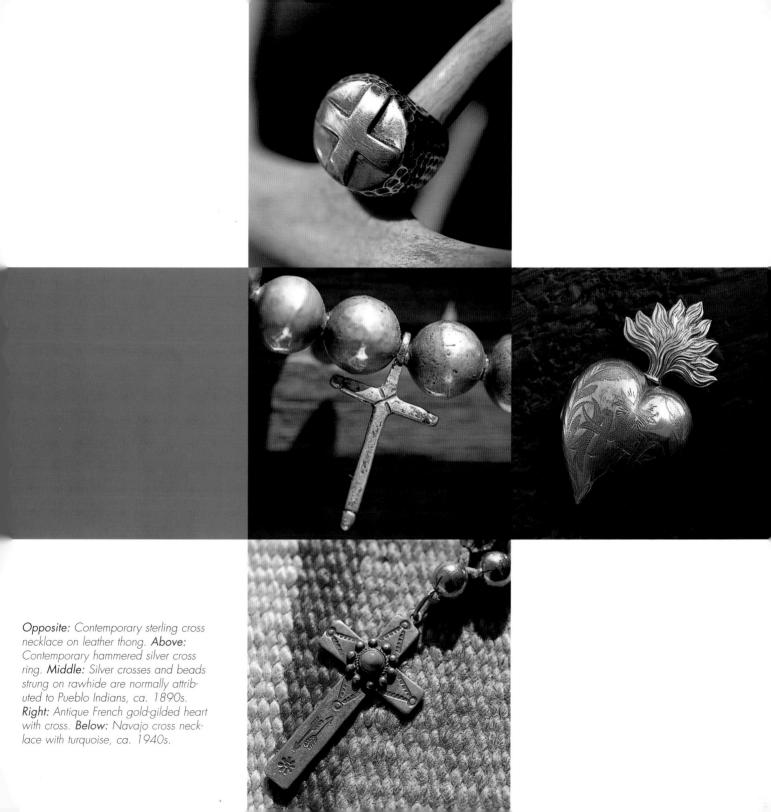

Opposite: Contemporary sterling cross necklace on leather thong. *Above:* Contemporary hammered silver cross ring. *Middle:* Silver crosses and beads strung on rawhide are normally attributed to Pueblo Indians, ca. 1890s. *Right:* Antique French gold-gilded heart with cross. *Below:* Navajo cross necklace with turquoise, ca. 1940s.

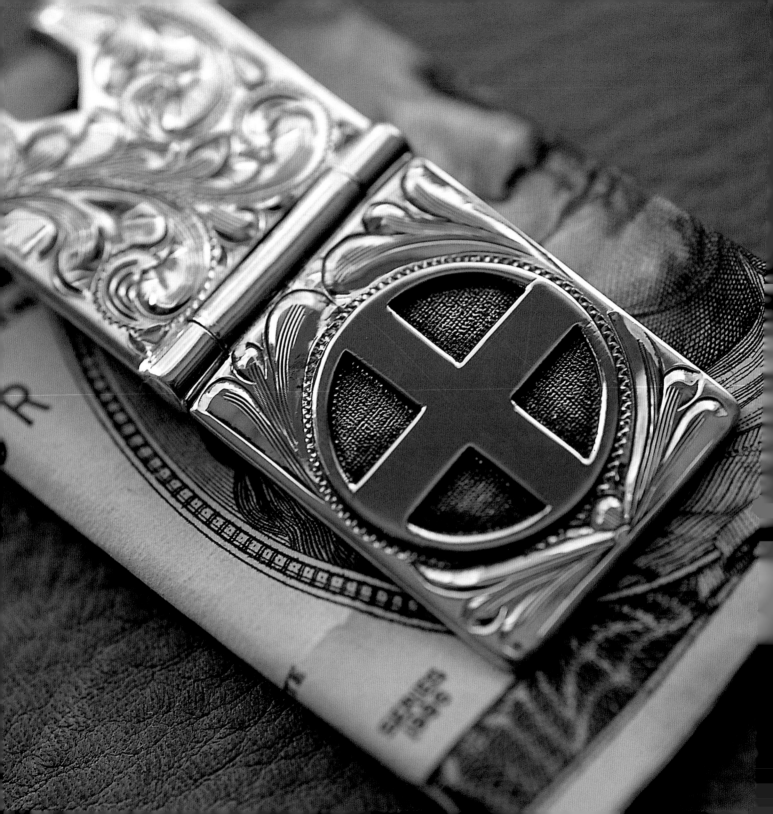

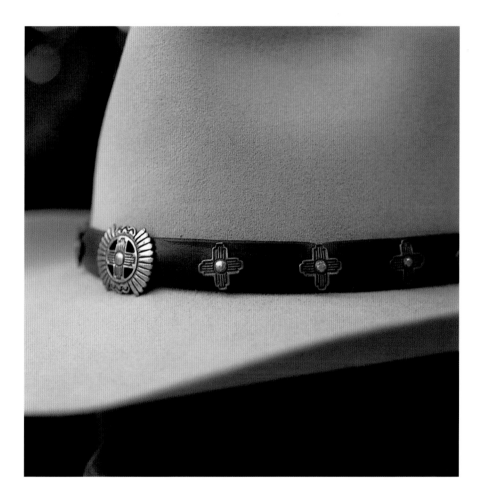

Opposite: Engraved sterling silver money clip with gold zia cross accent.
Right: Contemporary hatband with zia crosses.

METAL, STONE
AND
WOOD

* * * * *

MATERIALS FROM THE EARTH have been shaped, hammered, carved, chiseled, filed and formed in every possible way.

From Prehistoric times, man used stone on stone to create designs like solstice rings and, of course, crosses as their reference stars.

Iron and bronze were hammered into crosses centuries ago, metalworkers from the time of the crusades bear this out. And, of course, there's the wooden cross, millenniums old and as young as yesterday. Hardly a day goes by without seeing a cross in one of these mediums.

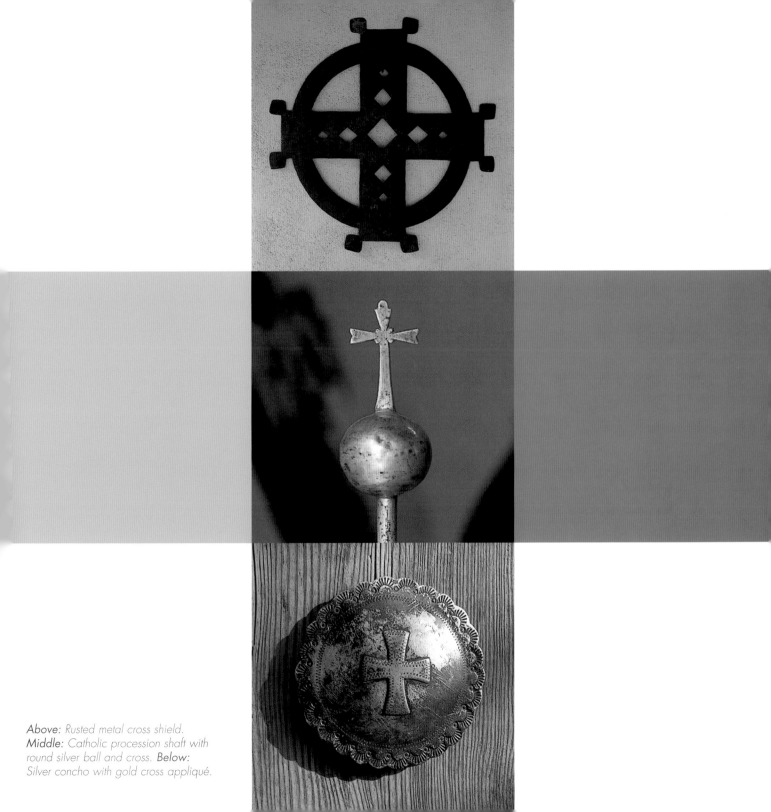

Above: Rusted metal cross shield.
Middle: Catholic procession shaft with round silver ball and cross. *Below:* Silver concho with gold cross appliqué.

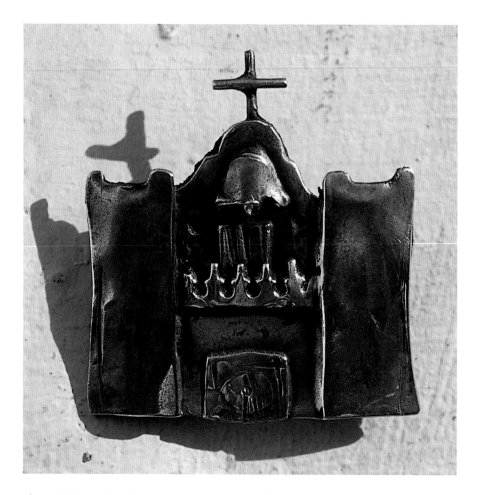

Above: Sterling silver church pin with cross on top. **Opposite:** *Mexican silver cross with turquoise and amethyst stones.*

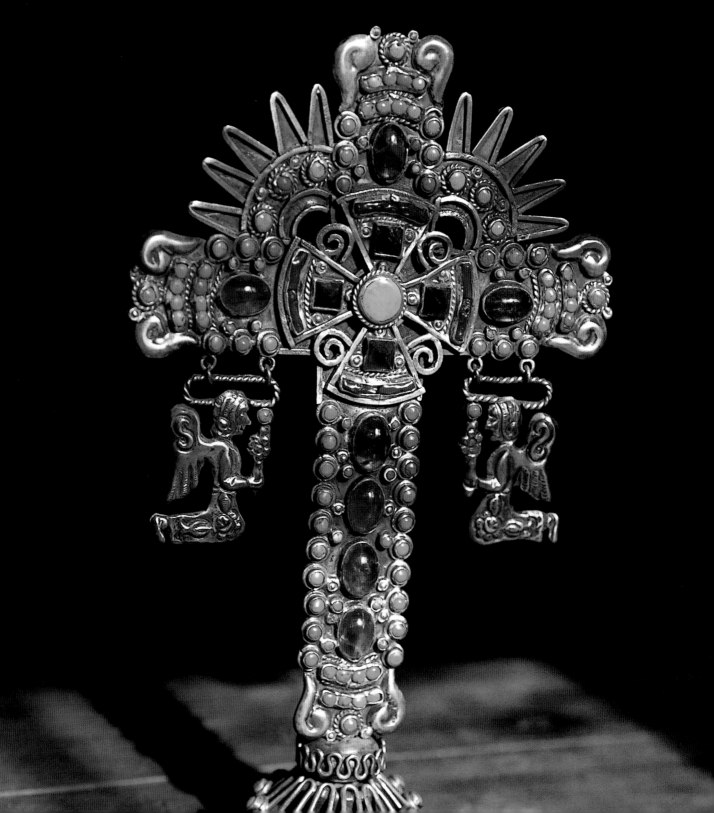

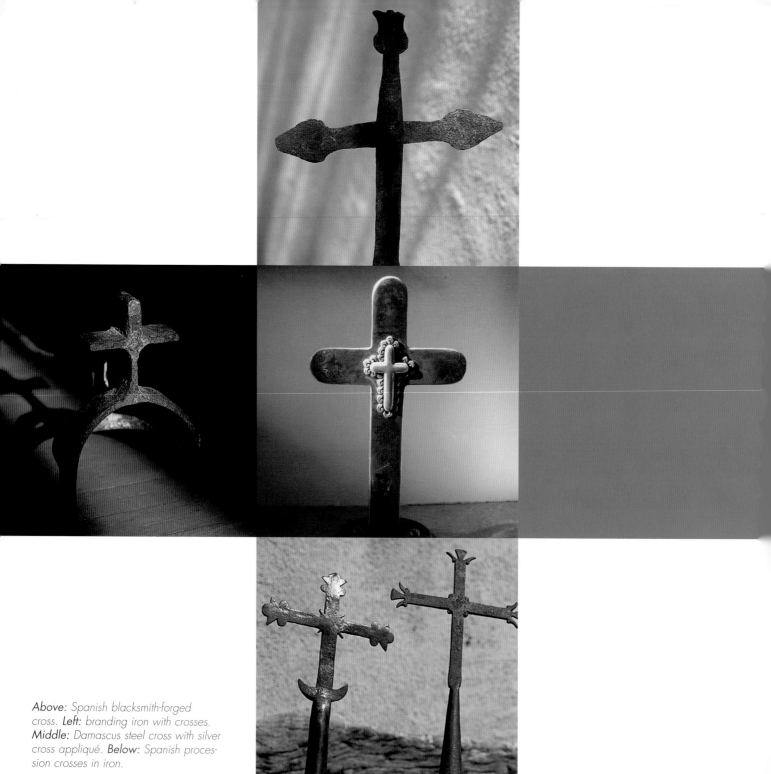

Above: Spanish blacksmith-forged cross. **Left:** branding iron with crosses. *Middle:* Damascus steel cross with silver cross appliqué. **Below:** Spanish procession crosses in iron.

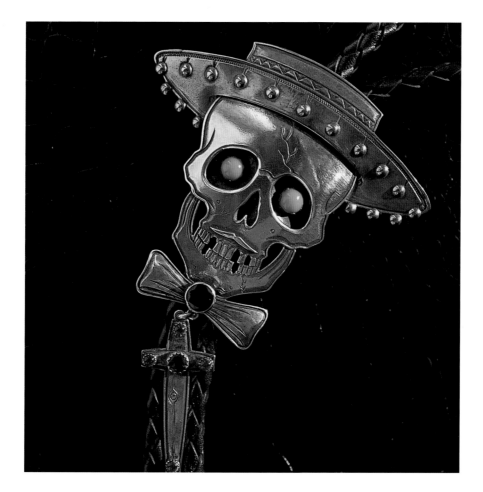

Day of the Dead bolo tie in sterling silver.

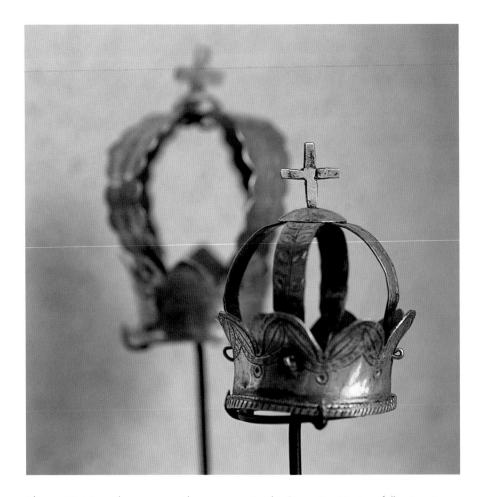

Above: Miniature silver crowns with crosses on stands. *Opposite:* Mexican folk art on tin Christmas tree with ornaments of stars, flowers, hearts and crosses.

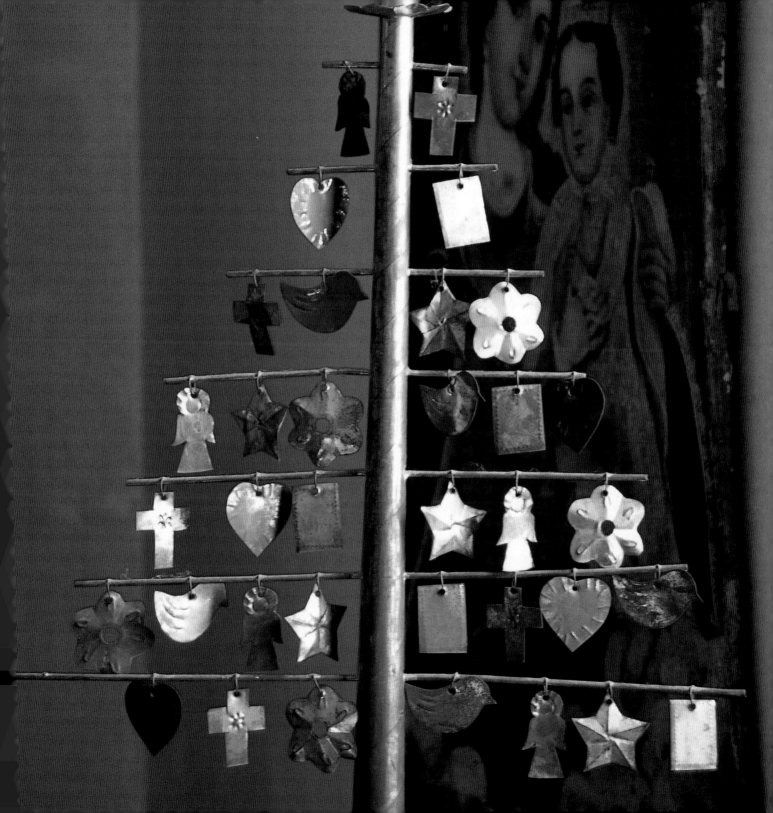

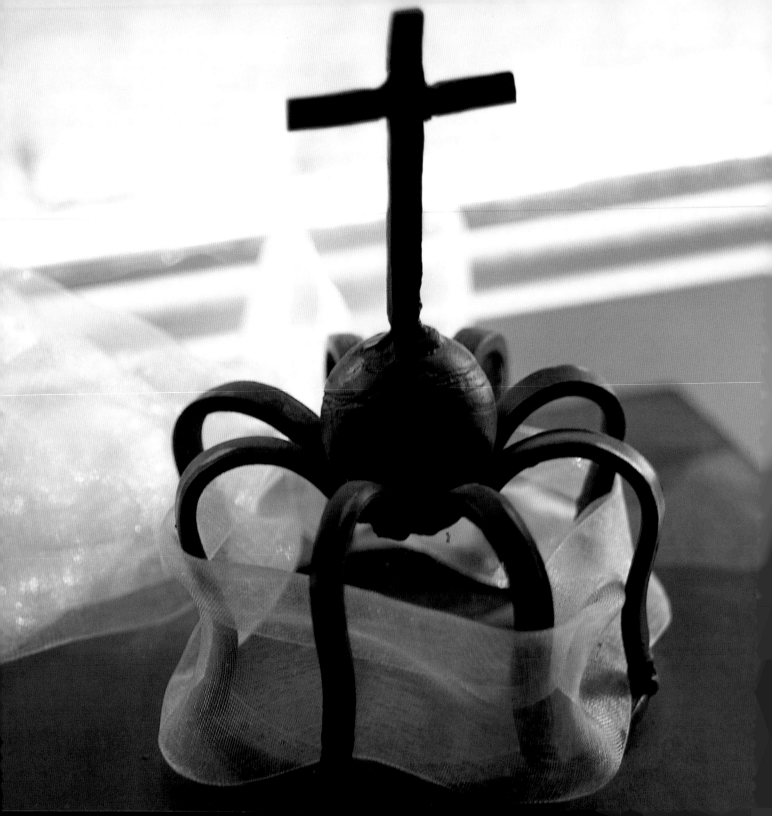

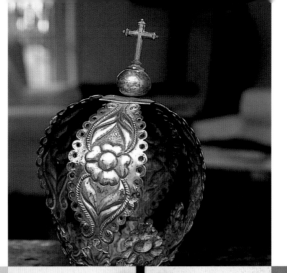

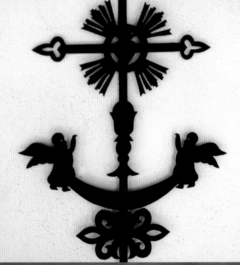

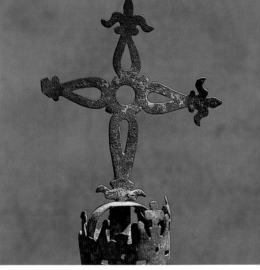

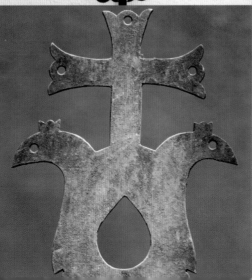

Opposite: A modern black iron crown cross adorns a black iron box. *Above:* Mexican embossed silver crown with ball and cross. *Middle:* Iron cross with angels *Right:* Antique open iron cross with fancy tips. *Below:* Rusted iron cross with birds.

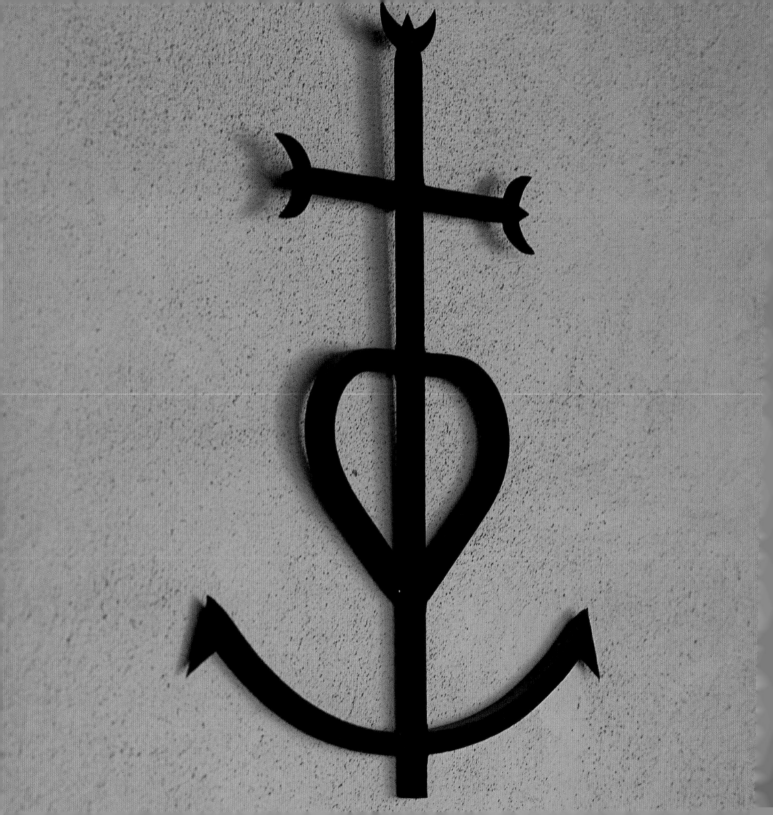

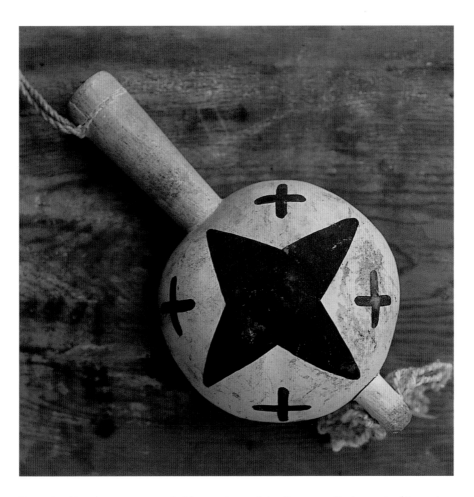

Opposite: French iron cross symbol for cowboys of the Camargue (in the south of France).
Above: Vintage Pueblo dance rattle with cross-inspired black and white design.

Above: Aged turquoise beads with antique cross. *Middle:* Sterling silver re-creation of a Catholic altar cross. *Right:* Modern folk art snake with black and white crosses. *Below:* Miniature pocketknife key chain.

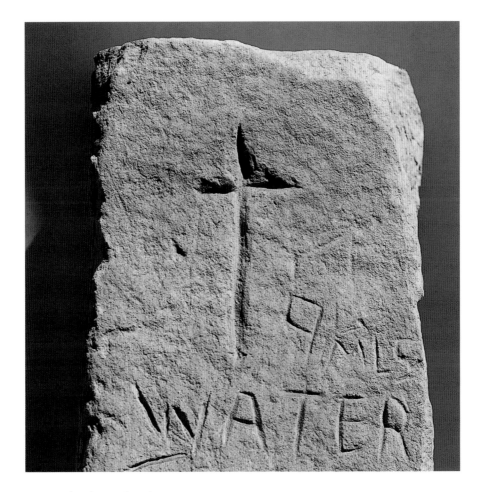

Mexican hand-carved marker stone, 1900s.

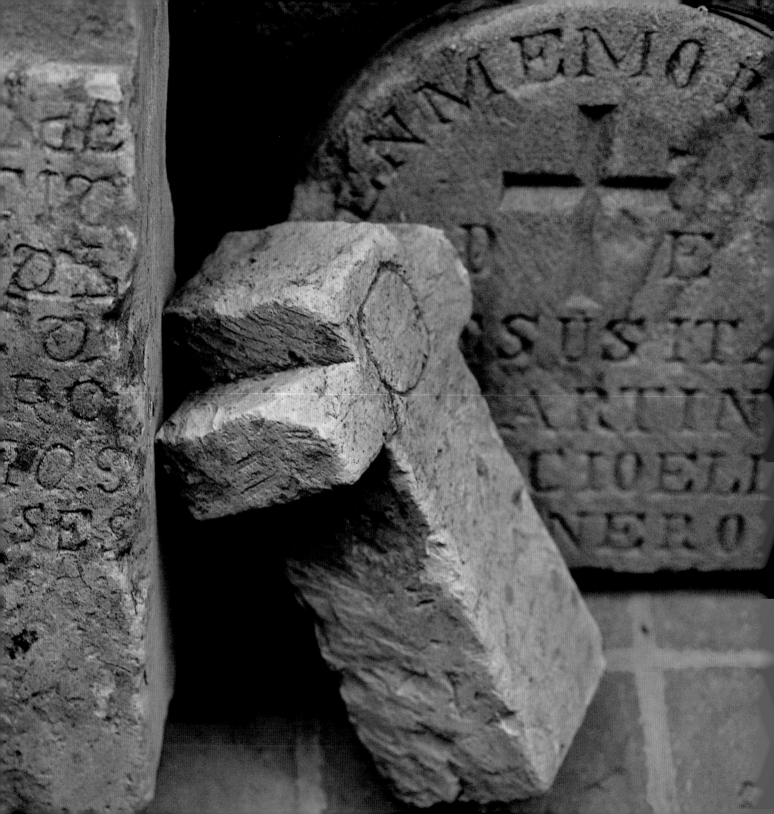

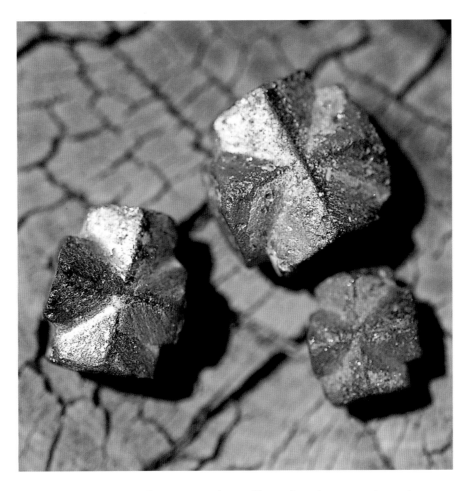

Opposite: Stone grave marker in a cross shape. ***Above:*** Staurolites—natural crystals.

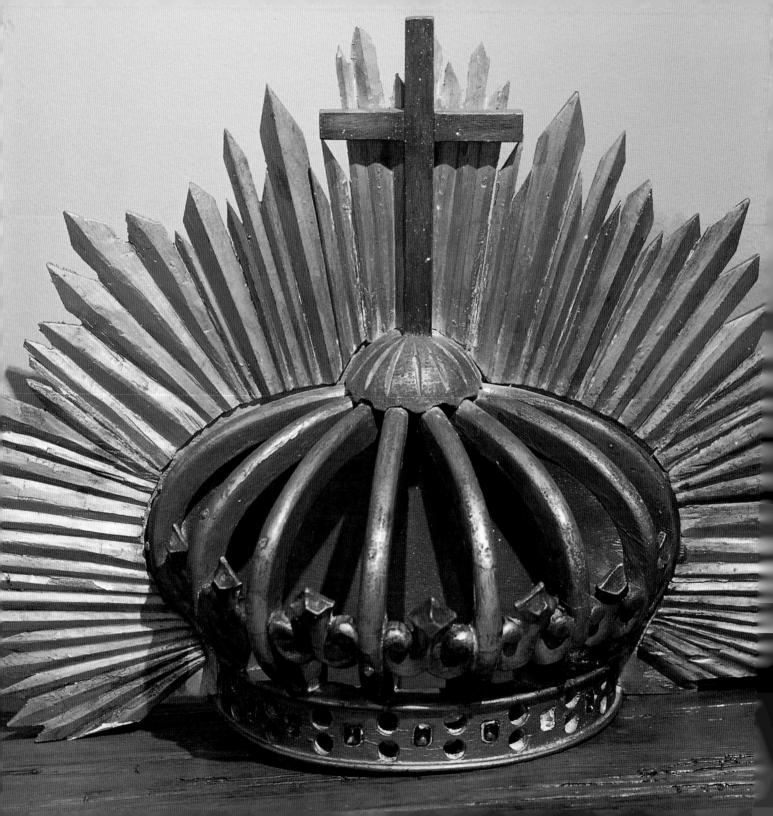

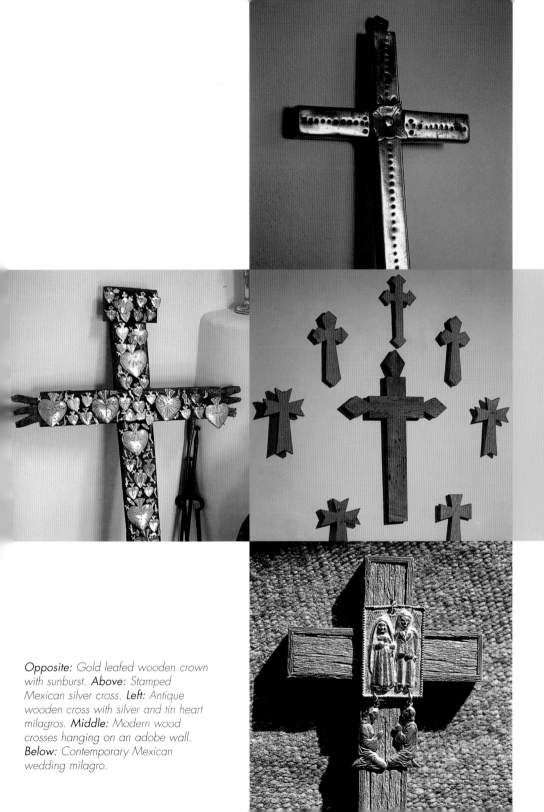

Opposite: Gold leafed wooden crown with sunburst. *Above:* Stamped Mexican silver cross. *Left:* Antique wooden cross with silver and tin heart milagros. *Middle:* Modern wood crosses hanging on an adobe wall. *Below:* Contemporary Mexican wedding milagro.

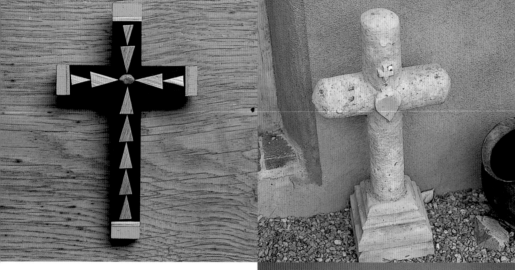

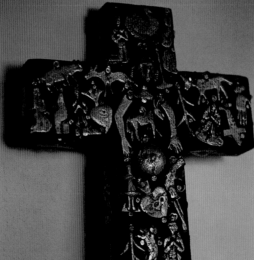

Above: Carved stone cross on oval background. *Left:* Traditional inlay cross with straw. *Middle:* Mexican concrete cross, ca. 1900. *Below:* Modern wood cross with a mix of tin Mexican milagros. *Opposite:* Navajo stamped-silver letter opener.

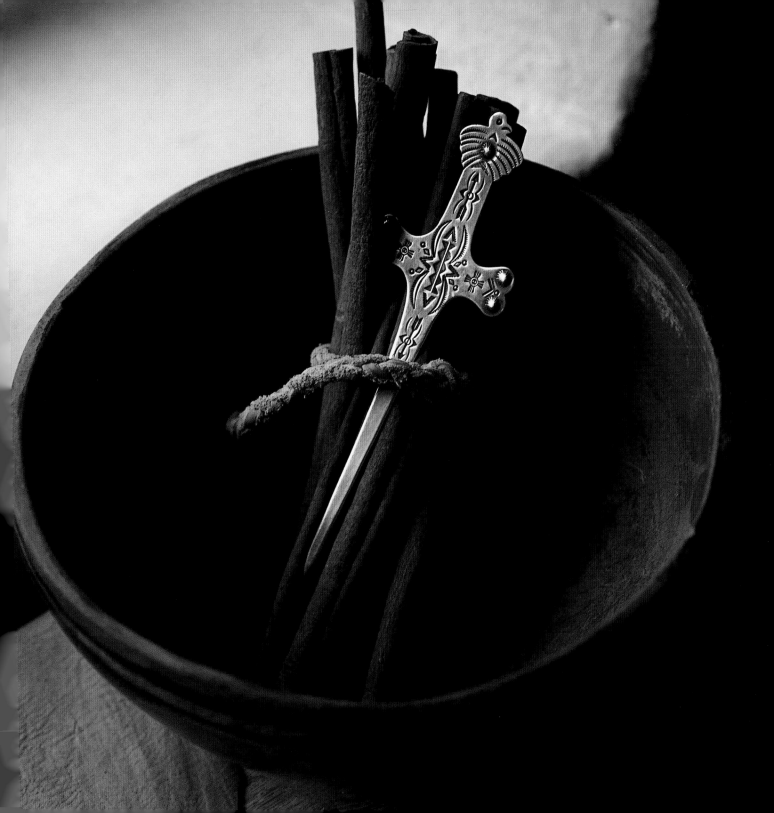

Above: Brass altar candleholder with cross on bottom. *Opposite:* Contemporary silver and tin heart milagros on blue wood crosses.

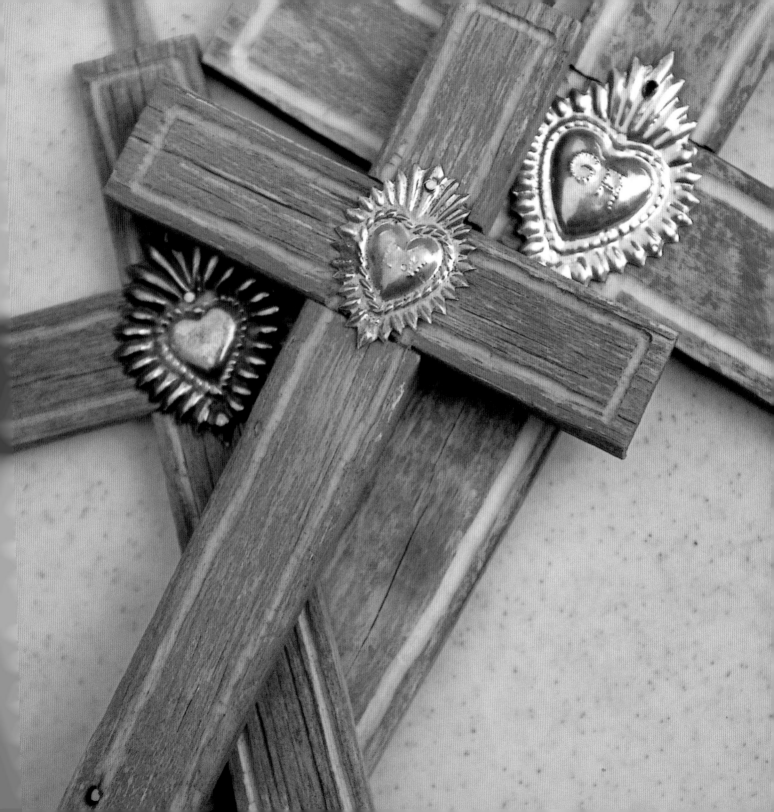

ARCHITECTURAL
AND
OUTDOOR
ORNAMENTS

◆ ◆ ◆ ◆ ◆

THE CROSS IN architecture can easily be traced to the Latin cross plan of the Roman Basilica: when viewed from above, the nave and two flanking sections half its size, plus the alter standing at the far end reveal the cross.

Romanesque, Gothic, Renaissance and Baroque to modern and postmodern styles were all influenced by Christianity and its symbols. Crosses top our churches and reside in our gardens where we go to relax or contemplate. Everywhere we look, we see this sign of comfort, reflection and timelessness.

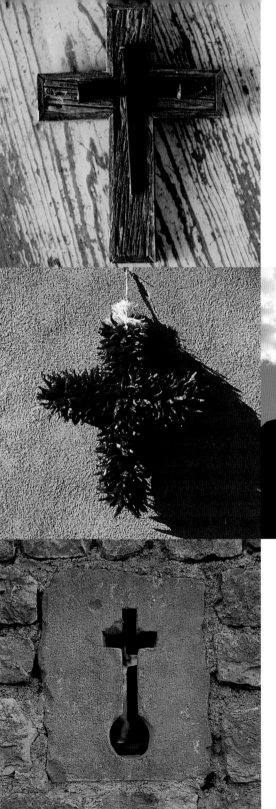

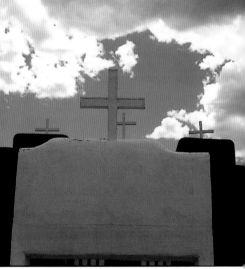

Above: Barnwood cross with horseshoe nails. *Middle:* Red chile pepper ristra in the form of a cross. *Right:* White wood crosses on a New Mexico adobe church. *Below:* Cross with stone embedded in a church wall in France.

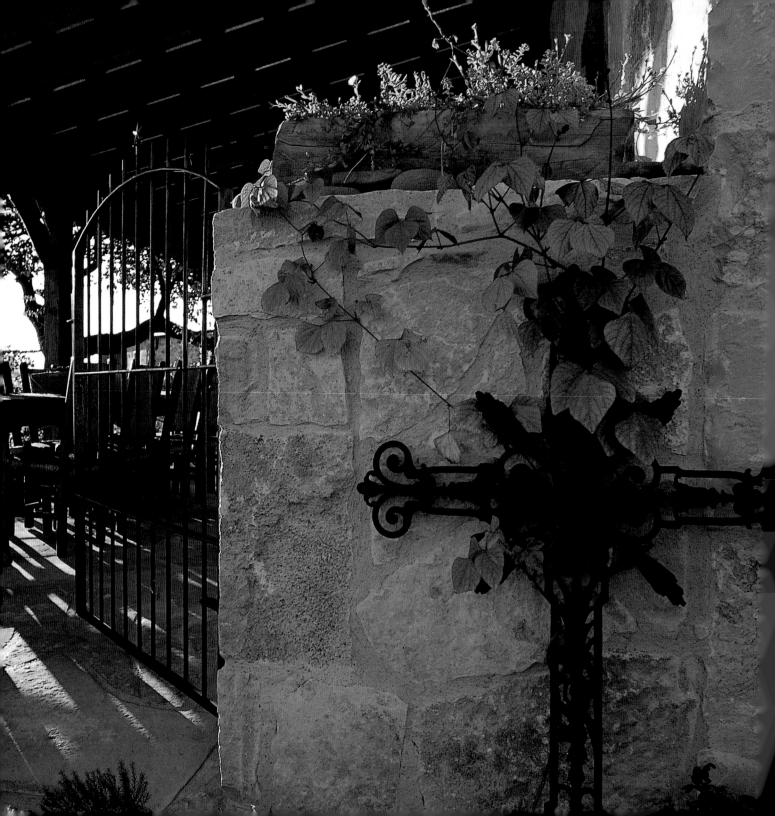

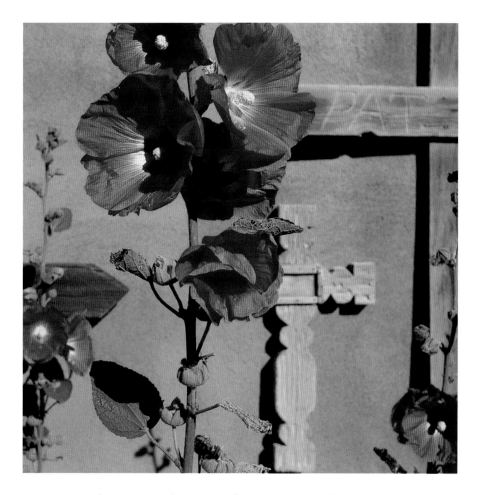

Opposite: French iron cross on limestone wall at a Texas home. **Above**: Contemporary wooden garden crosses with hollyhocks.

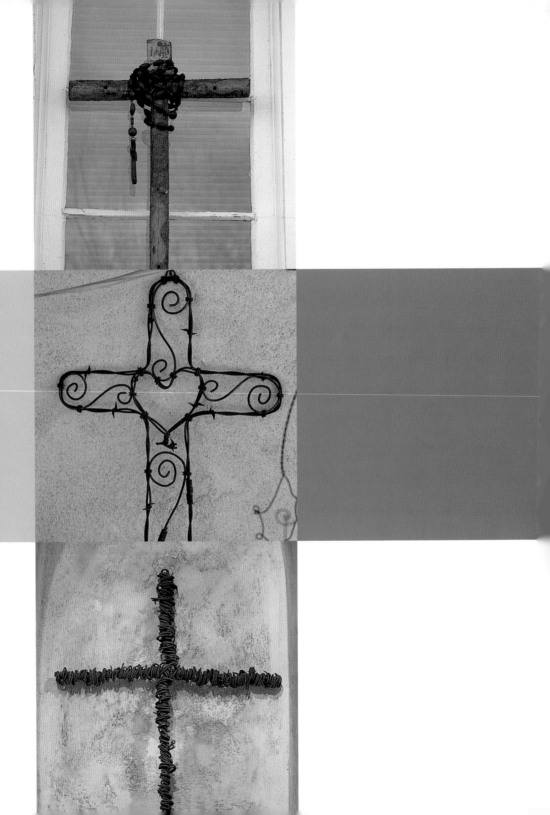

Above: Antique piñon-wood cross with wooden beaded rosary. *Middle:* Modern decorative barbwire cross with heart in middle. *Below:* Rusted wire wrapped around a rod to form a cross. *Opposite:* St. Francis Cathedral in Santa Fe.

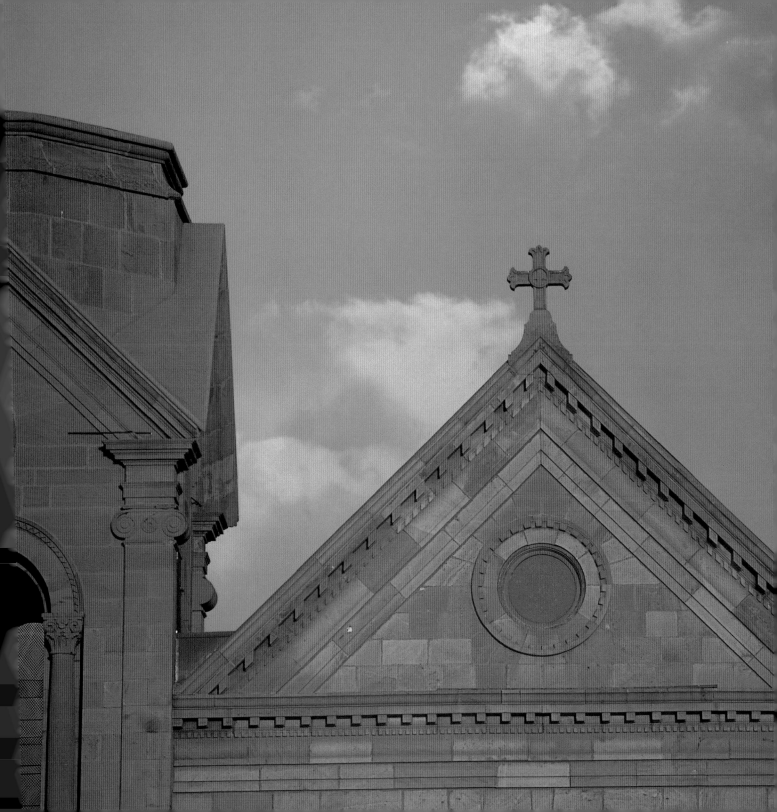

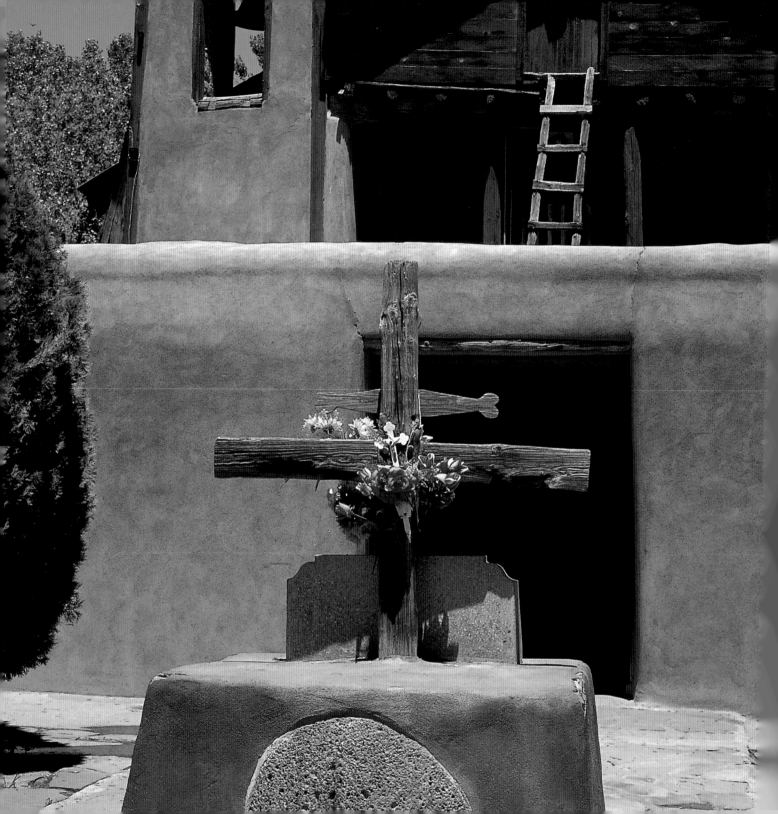

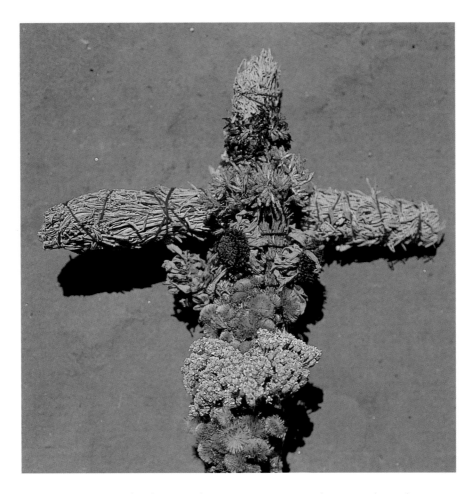

Opposite: Sanctuario de Chimayo, Chimayo, New Mexico. ***Above:*** Smudge stick—a
sweetgrass-and-sage cross with a mix of herbs.

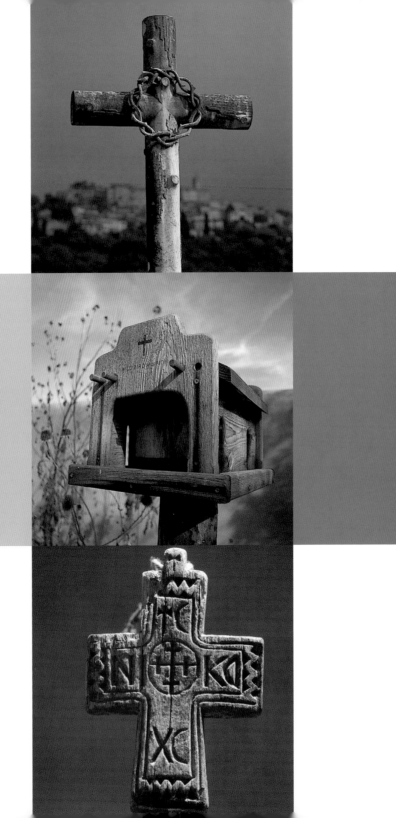

Above: Old concrete French village cross. *Middle:* Handcrafted wood "old mission" bird feeder with cross. *Below:* Mission carved-wood cross, ca. 1915.